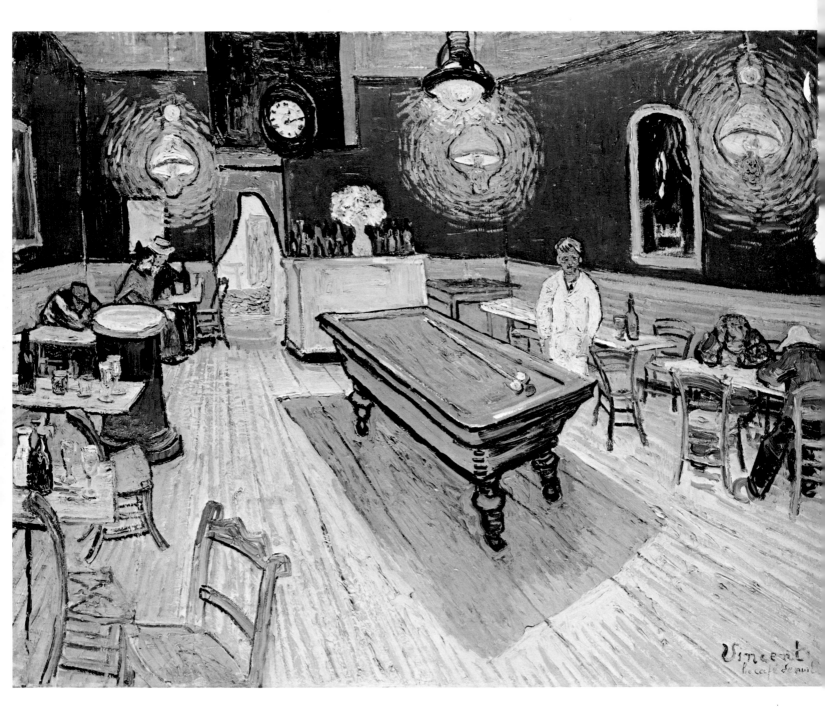

Vincent van Gogh, *Le Café de Nuit*, 1888 (p. 11)

French and School of Paris Paintings in the Yale University Art Gallery

A catalogue raisonné by Françoise Forster-Hahn

New Haven and London: Yale University Press: 1968

Designed by Alvin Eisenman,
Set in Monotype Aldine Bembo type
by the Press of A. Colish, Mount Vernon, New York.
Printed in the United States of America by
The Carl Purington Rollins Printing-Office of the Yale University Press.

Library of Congress catalog card number: 68-13907.

The publication of this catalogue has been made possible
by a contribution from an anonymous donor.

Contents

List of Plates

Foreword

This catalogue is the first part of a larger projected catalogue of all the Yale Art Gallery's collection of painting and sculpture. In this French section, prepared by Françoise Forster, only artists born before 1888 have been included. French and School of Paris artists born after this date will be included in a twentieth-century section to be published at a later date, and they will then be treated in association with artists from all schools. The manuscript for the present catalogue was completed in 1964.

The listing of artists is alphabetical. Capsule biographies of artists have not been included, since there are now available so many books of reference dealing with most of the artists here referred to.

Mrs. Forster would like to take this opportunity to thank all the donors of paintings, dealers, curators of other museums and art librarians, all too numerous to mention by name, who have assisted her in her researches for this volume.

It is hoped that this catalogue, and the more comprehensive one to follow in a few years' time, will greatly extend the knowledge and the usefulness of our collections for the student at Yale and the public in general.

Andrew C. Ritchie
Director

Explanatory notes

Title	Titles in French have been retained for ease of bibliographical reference. Where it was thought to be necessary they have been translated into English and placed in parentheses. In cases where the original French title is unknown, only the English title has been given.
Donor	Where the donor is or was a Yale graduate his degree and the date of his graduation follows his name.
Dimensions	Height precedes width. Dimensions are given in millimeters followed by inches.
Condition	Because it was not yet possible to examine the French and School of Paris paintings by means of a comprehensive technical analysis, no report on the present condition of a picture is given unless fundamental alterations have occurred.
Provenance	The information for the provenance for most of the paintings has kindly been provided by the cooperation of many galleries, art dealers, and donors. Unless it is otherwise stated, the source of information is the files of the Yale University Art Gallery.
Exhibition	For repetitions of the same exhibition of the Société Anonyme Collections which toured a number of cities, short titles have been given. The itineraries of these exhibitions are as follows:

TRAVELLING EXHIBITION 1945-46: *Modern Art from the Collection of the Société Anonyme:* South Hadley, Mass., Mount Holyoke College; Northampton, Mass., Smith College; Amherst, Mass., University of Massachusetts; New London, Conn., Lyman Allyn Museum.

TRAVELLING EXHIBITION 1946-47: *Abstract and Cubist Art:* Durham, N.C., Duke University; Charlotte, N.C., Mint Museum of Art; Raleigh, N.C., State Art Gallery; Charleston, S.C., Gibbes Art Gallery; Williamsburg, Va., College of William and Mary; Chapel Hill, N.C., University of North Carolina; Tuscaloosa, Ala., University of Alabama; St. Louis, Mo., Washington University; Northfield, Minn., Carleton College; St. Paul, Minn., Hamline University Galleries.

TRAVELLING EXHIBITION 1945-46: *Duchamp, Duchamp-Villon, Villon:* Williamsburg, Va., College of William and Mary; San Francisco, Cal., California School of Fine Arts; Meadville, Pa., Allegheny College; Northfield, Minn., Carleton College; St. Paul, Minn., St. Paul Gallery and School of Art; Orono, Me., University of Maine.

Translations	Those quotations in the commentaries of Léger, Redon, and Villon, taken from French sources, have been translated by the author.

Pierre Bonnard

Fontenay-aux-Roses (Seine) 1867 –
Cannet (Alpes-Maritimes) 1947

PLACE PIGALLE, LA NUIT, C. 1905–08 (PLATE 23).
(Place Pigalle, At Night)

Gift of Walter Bareiss, B.S. 1940. Acc. No. 1955.23.1.
Oil on wood panel; 575 x 684 mm. (22⅝ x 26 15/16 in.).
Inscriptions: Signed at bottom left: *Bonnard.*
Provenance: Octave Mirbeau, Paris; Gérard; de Wolmann; anonymous; Bernheim-Jeune, Paris; Walter Bareiss, New York (bought from Bernheim-Jeune in 1952). (Provenance according to Bareiss, letter, November 29, 1963.)
Bibliography: "Accessions 1955," *Bulletin,* Y.U.A.G., *22* (March, 1956), p. 7; P. Courthion, *Paris in Our Time* (Lausanne, 1957), p. 67 [illustrated as *Paris, View by Night, 1900*].

Place Pigalle, la nuit depicts a spot in Montmartre not far from Bonnard's studio on rue de Douai. During his early period, Bonnard very often painted and lithographed scenes of the life in the streets and squares of Paris; among them were several night scenes, the majority of which were painted between 1890 and 1900. This might have led P. Courthion to his earlier date of 1900. The Yale picture, however, is a very late one in this group, although Bernheim-Jeune's date "about 1911" seems too late.[1] The realistic perspective and the structure of the composition as well as the sharp silhouette of the woman in the foreground and the color scheme suggest a date about 1905–08.

1. Letter, Bernheim-Jeune, January 23, 1964.

Eugène Louis Boudin

Honfleur 1824 – Paris 1898

TROUVILLE, C. 1865–70 (PLATE 10).

Gift of Mrs. Joseph M. Flint. Acc. No. 1945.274.
Oil on wood panel; 318 x 413 mm. (12½ x 16¼ in.).
Inscriptions: Signed at bottom left: *E. Boudin;* and inscribed at bottom right: *Trouville;* on the reverse, a torn label: *Dura——*[Durand-Ruel?] / *Paris 16, New York . . .* / *Boudin* / *Place de l'Hôtel . . .* [de ville?] / *Trouville.*
Provenance: Probably Durand-Ruel, Paris; Mrs. Joseph M. Flint, New Haven, Conn.

This painting is related in style and composition to other views of Trouville painted by Boudin between 1865 and 1870.

BEACH SCENE, C. 1874–75 (PLATE 11).

Gift of Edward B. Greene, B.A. 1900. Acc. No. 1941.309.
Oil on wood panel; 239 x 369 mm. (9⅜ x 14½ in.).
Inscriptions: Signed at bottom right: *E. Boudin;* stamped on reverse: *Felix Gérard Fils* / *Tableaux* / *7 Rue Lafitte* / *Paris.*
Provenance: Edward B. Greene, Cleveland, Ohio.

There is a very similar scene, dated 1874 (reproduced in *Art News, 29,* Supplement, May 16, 1931, p. 92. It was then in the collection of Josef Stransky, New York).

HARBOUR SCENE WITH SHIPS, C. 1875 (PLATE 11).

Gift of Miss Jessie M. Tilney in memory of her grandparents, John William and Hannah M. Mason. Acc. No. 1938.25.
Oil on wood panel; 261 x 353 mm. (10¼ x 13⅞ in.).
Inscriptions: Signed at bottom left: *E. Boudin.*
Provenance: John William Mason, New York; Jessie M. Tilney, New York (by family descent).
Bibliography: Probably R. L. Benjamin, *E. Boudin* (New York, 1937), p. 189 [as *Shipping Scene*].

This painting was on loan to the Brooklyn Museum, 1935–38, under the title *Shipping Scene.*

Georges Braque

Argenteuil-sur-Seine 1882 – Paris 1963

LE POÊLE, 1942–43 (PLATE 43).
(The Stove)

Gift of Paul Rosenberg & Co., in memory of Paul Rosenberg. Acc. No. 1960.34.

Oil on canvas; 1457 x 883 mm. (57⅜ x 34¾ in.).

Inscriptions: Signed at bottom left: *G. Braque.*

Provenance: Paul Rosenberg & Co., New York (bought from the artist in 1952). (Letter from P. Rosenberg & Co., October 15, 1964.)

Exhibitions: Paris, *Salon d'Automne*, 1943, no. 1779; Amsterdam, Stedelijk Museum, *Georges Braque*, 1945, no. 10; London, Tate Gallery, *Braque and Rouault*, 1946, no. 7; Avignon, Palais des Papes, *Exposition de peintures et sculptures contemporaines*, 1947, no. 18; Venice, XXIV Biennale di Venezia, 1948, no. 15; Cleveland, Museum of Art, and New York, Museum of Modern Art, *Georges Braque*, 1949, no. 81 [illustrated]; New York, Paul Rosenberg & Co., *Paintings by Braque from 1924-1952*, 1952, no. 17; Zurich, Kunsthaus, *Braque*, 1953, no. 110; New York, Paul Rosenberg & Co., *Paintings by Braque*, 1955, no. 15; New York, Knoedler, *The Late Years (1940-63) and the Sculpture, Georges Braque 1882-1963, An American Tribute* (Exhibition arranged for the Public Education Association), 1964, no. 12 [illustrated].

Bibliography: *Cahiers d'Art 15-19* (1940-44), p. 103 [illustrated]; J. Paulhan, *Braque, le patron* (Geneva and Paris, 1946), p. 161 [illustrated]; S. Fumet, *Braque* (Paris and New York, 1946), pl. 11; M. Gieure, *Georges Braques* (Paris and New York, 1956), pp. 76, 119, pl. III; J. Cassou, *Braque* (Munich, Vienna, and Basel, 1956), pl. 27; J. Flanner, *Men and Monuments* (New York, 1957), p. 163; Galerie A. Maeght, Paris, ed., *Catalogue de l'oeuvre, peintures 1936-57* (1960), vol. 1942-47, no. 6 [illustrated]; "Accessions of American and Canadian Museums," *Art Quarterly*, 24 (Spring 1961), p. 114 [illustrated]; "Recent Gifts and Purchases," *Bulletin*, Y.U.A.G., 26 (December, 1961), p. 32 [illustrated]; J. Richardson, *Georges Braque* (New York, 1961), p. 27, pl. 49.

Taking refuge from the German invasion of 1940, Braque went first to the Limousin and then to the Pyrenees. In the fall, however, he returned to Paris, where he stayed during the occupation. The *Salon d'Automne* (1943) dedicated a whole room to his work; the *Stove* was among the exhibited paintings. All the objects are firmly outlined and painted with violent, broad brush strokes. The white canvas is uncovered in some parts of the wall, the stove, and along the stove-pipe. The vertical format recalls the earlier Guéridon still lifes and some other dusky interiors all of 1942-44, such as *La Table de cuisine* (1942), *La Table de cuisine au gril* (1943-44), *La Toilette aux carreaux verts* (1942-44).[1] During the war years the common domestic objects and the austere interiors showing the utilitarian parts of the house gained a new importance in Braque's work.

1. All reproduced in Maeght's catalogue (1960), vol. 1942-47, nos. 7, 71, 70.

Eugène Carrière
Gournay (Seine-et-Marne) 1849 – Paris 1906

PORTRAIT OF PAUL GAUGUIN, 1891 (PLATE 20).

Gift of the Estate of Fred T. Murphy, B.A. 1897. Acc. No. 1957.5.1.

Oil on canvas; 546 x 654 mm. (21½ x 25¾ in.).

Condition: Recently mounted on aluminum.

Inscriptions: Inscribed at top left: *au peintre et ami Gauguin / Eugène Carrière.*

Provenance: Emile Gauguin (until 1921; *The Intimate Journals of Paul Gauguin*, 1931); Fred T. Murphy, Wayne County, Michigan.

Bibliography: C. Morice, *Paul Gauguin* (Paris, 1920), p. 43; *The Intimate Journals of Paul Gauguin*, with a Preface by Emile Gauguin (London, 1931), p. iii; H. Read, "Gauguin, Return to Symbolism," *Art News Annual*, 25 (1956), p. 128 [illustrated]; R. Goldwater, *Paul Gauguin* (New York, 1957), p. 11 [illustrated]; "New Acquisitions Issue," *Bulletin*, Y.U.A.G., 24 (1958), p. 34; J. Rewald, *Post-Impressionism, from van Gogh to Gauguin* (2nd ed. New York, 1962), pp. 457-58 [illustrated].

Emile Gauguin, son of Paul, tells us that his father gave this portrait to him, when he visited his family in Copenhagen "to bid us adieu before his last trip to Tahiti," which would have been in 1894.[1] But Emile is certainly mistaken about the date. Carrière must

have painted the portrait when Gauguin was in touch with the symbolist group in the winter of 1890–91 and, as Emile states, Gauguin brought it to Copenhagen that same year, namely in February–March 1891 before his first trip to Tahiti.

Carrière and Gauguin knew each other for a very short time during the winter of 1890–91. Gauguin, who had left Le Pouldu in Brittany at the end of 1890, stayed in Paris until his first departure to Tahiti on April 4, 1891. During this period he had some contact with the symbolist group then gathering at the Café Voltaire around Verlaine. He became particularly friendly with Carrière who painted the portrait of Verlaine that same year and who offered spontaneously to paint Gauguin's portrait.[2] In return Gauguin gave Carrière a self-portrait dedicated to him.[3] On March 23, 1891 the symbolists gave in Gauguin's honor a farewell banquet, presided over by Mallarmé. About thirty artists participated, among them Carrière, who later expressed his admiration for Gauguin in an article in the *Mercure de France* in November 1903, the year of Gauguin's death.[4]

1. *The Intimate Journals* (1931), p. iii.
2. C. Morice, *Paul Gauguin* (1920), p. 43.
3. Rewald, *Post-Impressionism* (1962), p. 456 [illustrated].
4. Reprinted in: Eugène Carrière, *Ecrits et lettres choisies* (4th ed. Paris, 1909), pp. 43 ff.

Paul Cézanne
Aix-en-Provence 1839 – 1906

PAYSAGE AVEC MOULIN À EAU, C. 1870–71 (PLATE 14).
(Landscape with Water Mill)

Gift of Walter Bareiss, B.S. 1940. Acc. No. 1952.48.1.

Oil on canvas; 413 x 543 mm. (16¼ x 21⅜ in.).

Provenance: Moderne Galerie Thannhauser, Munich (from about 1917–21); Levin, Breslau; Richard Zinser, New York (from about 1936–40); Mr. and Mrs. Walter Bareiss, New York. (Provenance according to Zinser, letter, January 12, 1963.)

Exhibitions: Providence, Museum of Art, Rhode Island School of Design, *Cézanne*, 1954, no. 11.

Bibliography: Munich, Moderne Galerie Heinrich Thannhauser, in *Nachtragswerk III zur grossen Katalogausgabe 1916* (Munich, 1918), p. 30 [illustrated]; J. Meier-Graefe, *Cézanne und sein Kreis* (Munich, 1922), p. 118 [illustrated]; G. Rivière, *Le Maître Paul Cézanne* (Paris, 1923), p. 200; K. Scheffler, "Breslauer Kunstleben," *Kunst und Kuenstler*, 21 (1923), pp. 132, 138 [illustrated]; L. Venturi, *Cézanne, son art, son oeuvre* (2 vols. Paris, 1936), 1, p. 77, no. 48; 2, pl. 10.

The small *Landscape with Water Mill*, still painted in dark, muddy tones, probably dates from about 1870–71. Rivière's date of 1872–73 is certainly too late, because at that time Cézanne had already begun to lighten his palette under Pissarro's influence. Just before Cézanne went to work with Pissarro, in 1872, he painted several "close-up views" of landscape motives, the *Landscape with Water Mill* being one of the last in this group.[1]

1. Cf. Venturi, *Cézanne* (1936), nos. 26–48; also K. Badt, *Die Kunst Cézannes* (Munich, 1956), p. 202.

LE CHEMIN DU VILLAGE, C. 1872–74 (PLATE 14).
(Village Road)

Bequest of Mrs. Kate Lancaster Brewster. Acc. No. 1948.120.

Oil on canvas; 381 x 470 mm. (15 x 18½ in.).

Inscriptions: Labelled on reverse middle: *Cézanne | la maison blanche | 1873;* and on reverse bottom left: *La Maison Blanche-Environs d'Auvers | Collections: Vollard | Cassirer (?) | In Switzerland | Bernheim Jeune & Cie 1928.*

Provenance: Père Portier, Paris (according to Blot, 1934, p. 13); Eugène Blot, Paris (sale, Paris, Hôtel Drouot, May 10, 1906, no. 15 [illustrated] to Pellerin for 3500 frs. according to "La Chronique des arts," May 19, 1906, p. 163); Auguste Pellerin, Paris; Moderne Galerie H. Thannhauser, Berlin and Munich; Paul Vallotton (until 1926; according to Bernheim-Jeune, letter, October 24, 1963); Bernheim-Jeune, Paris; Walter S. Brewster, Chicago (bought in 1928 from Bernheim-Jeune). (The provenance as indicated by the label on reverse cannot be traced today.)

Exhibitions: Paris, Bernheim-Jeune, *Exposition Rétrospective Paul Cézanne*, 1926, no. 45 [as *La Route à Auvers*]; Berlin, Galerie M. Goldschmidt & Co., *Monet und der Impressionismus*, 1928; South Hadley, Mass., Mount Holyoke College, 1956.

Bibliography: "La Chronique des arts," in *Gazette des Beaux Arts*, 3. période, *36* (1906), p. 163; Munich, Moderne Galerie Heinrich Thannhauser, in *Nachtragswerk II zur grossen Katalogausgabe 1916* (Munich, 1917), pl. 15; G. Rivière, *Le Maître Paul Cézanne* (Paris, 1923), p. 203 [as *Le Chemin du village. Aux Environs de Pontoise*, 1875-76]; W. Wolfradt, "Monet und der Impressionismus. Zu den Ausstellungen der Berliner Galerien Thannhauser und M. Goldschmidt & Co.," *Cicerone*, *20* (1928), p. 134, no. 4 [illustrated]; E. Blot, *Histoire d'une collection de tableaux modernes, 50 ans de peinture (de 1882-1932)* (Paris, 1934), p. 13; L. Venturi, *Cézanne, son art, son oeuvre* (2 vols. Paris, 1936), *1*, p. 98, no. 141; *2*, pl. 37; "Accessions 1947-48," *Bulletin*, Y.U.A.G., *16* (July, 1948) [illustrated].

Chemin du village belongs to a group of paintings, all done at roughly the same time, whose main motif is the street.[1] It probably dates from the time Cézanne worked together with Pissarro in Pontoise, 1872-74.

1. Cf. Venturi, *Cézanne* (1936), *1*, nos. 134-35, 137, 140-41, 144-45, 147.

Jean-Baptiste-Camille Corot
Paris 1796 – 1875

LE PORT DE LA ROCHELLE, 1851 (PLATE 5).
(The Harbor of La Rochelle)

Bequest of Stephen C. Clark, B.A. 1903. Acc. No. 1961.18.14.

Oil on canvas; 505 x 718 mm. (19⅞ x 28¼ in.).

Inscriptions: Signed at bottom right: COROT.

Provenance: Alfred Robaut, Paris (bought from the artist in 1868); C. Dutilleux, Paris (sale, Paris, Hôtel Drouot, March 26, 1874, no. 23 [withdrawn]); Durand-Ruel, New York; Baron Nathaniel de Rothschild; Baron Léonine Henri de Rothschild; Wildenstein, New York; Stephen C. Clark, New York.

Exhibitions: Paris, *Salon*, 1852, no. 283; Rouen, 1856; Toulouse, 1865; Amiens, 1868; Arras, 1868; Paris, Ecole des Beaux-Arts, *Exposition posthume . . .*, 1875, no. 97; Paris, Durand-Ruel, *Exposition rétrospective*, 1878, no. 95; Paris, *Exposition universelle, centenale de l'art français*, 1889, no. 155; Paris, Paul Rosenberg, *Paysages de France et figures*, 1930, no. 21; Paris, Paul Rosenberg, *Exposition grands maîtres du XIXe siècle*, 1931, no. 11; New York, Durand-Ruel, *Exhibition of Important Paintings by Great French Masters of the XIXth Century*, 1934, no. 5; New York, Knoedler, *Figure and Landscape Paintings by Corot*, 1934, no. 9 [illustrated]; New York, Century Club, *French Masterpieces, 1850-1900*, 1936, no. 12; New York, World's Fair, *Masterpieces of Art*, 1940, no. 253 [illustrated]; New York, Wildenstein, *The Serene World of Corot*, 1942, no. 22 [illustrated]; Philadelphia, Museum of Art, *Corot*, 1946, no. 26 [illustrated]; New Haven, Y.U.A.G., *French Paintings of the Latter Half of the XIXth Century from the Collections of Alumni and Friends of Yale*, 1950, no. 4 [illustrated]; New York, Knoedler, *A Collector's Taste*, 1954, no. 5 [illustrated]; Paris, Musée de l'Orangerie, *De David à Toulouse-Lautrec*, 1955, no. 8 [illustrated]; New Haven, Y.U.A.G., *Paintings, Drawings and Sculpture Collected by Yale Alumni*, 1960, no. 39 [illustrated]; Chicago, Art Institute, *Corot*, 1960, no. 76.

Bibliography: T. Sylvestre, *Histoire des artistes vivants* (Paris, 1856), p. 404; P. Mantz, "Corot," *Gazette des Beaux Arts*, 1. période, *11* (1861), pp. 429, 431 [illustrated]; H. Dumesnil, *Corot, souvenirs intimes* (Paris, 1875), p. 126, no. 58; T. Sylvestre, *Histoire des artistes vivants* (Paris, 1878), p. 265; L. Roger-Milès, *Corot* (Paris, 1891), pp. 46, 83; L. Roger-Milès, *Album classique des chefs-d'oeuvre de Corot* (Paris and New York, 1895) [illustrated]; A. Robaut, *L'Œuvre de Corot, catalogue raisonné et illustré, précédé de l'histoire de Corot et de ses oeuvres par Etienne Moreau-Nélaton* (4 vols. Paris, 1905), *1*, pp. 128-32, 137-38; *2*, p. 230, no. 669 [illustrated]; E. Moreau-Nélaton, *Corot raconté par lui-même* (2 vols. Paris, 1924), *1*, pp. 76-77, 82, fig. 118; M. Lafargue, *Corot* (Paris, 1925), p. 39, pl. 25; J. Meier-Graefe, *Corot* (Berlin, 1930), p. 69; E. Faure, *Corot* (Paris, 1931), p. 50, pl. 53; René-Jean, *Corot* (Paris, 1931), pl. 36; [P. Courthion], *Corot, raconté par lui-même et par ses amis* (2 vols. Geneva, 1946), *1*, p. 60; *2*, p. 145; G. Bazin, *Corot* (2nd ed. Paris, 1951), pp. 48, 128, no. 85 [illustrated]; D. Baud-Bovy, *Corot* (Geneva, 1957), p. 220; G. de Traz, *Corot* (Elsevier, 1958), p. 160, no. 52 [illustrated]; A.

Coquis, *Corot et la critique contemporaine* (Paris, 1959), p. 61; "Yale Exhibits Clark Bequest," *Art Journal*, 21 (1961-62), p. 118 [illustrated]; "La Chronique des Arts" in *Gazette des Beaux Arts*, 6. période, 59 (February, 1962), p. 38, no. 141 [illustrated]; Jean Leymarie, *French Painting, the Nineteenth Century* (Geneva, 1962), p. 109 [illustrated]; "Recent Gifts and Purchases," *Bulletin*, Y.U.A.G., 28 (December, 1962), p. 13 [illustrated].

In the summer of 1851 Corot spent some time with Comairas and Brizard in La Rochelle, a site favored by Claude Joseph Vernet in the late eighteenth century and later by Signac, Renoir, and others. Corot painted several views of the harbor.[1] The Yale painting shows the basin of the harbor flanked by two towers, one to the left, the *Tour Saint Nicolas*, and to the right the *Tour de la Chaîne*. It was painted from a second-story window of the house at 6, Quai Vallin, where Corot worked for ten or twelve sessions of three or four hours each.[2] The artist himself considered it "un des meilleurs du magasin"[3] and sent it to various exhibitions in the provincial towns; A. Robaut acquired it in Arras in 1868. It was Corot's first plein-air painting of a French scene to be exhibited.

1. Cf. Robaut, *Corot* (1905), 2, nos. 669-73, 676.
2. Moreau-Nélaton, *Corot* (1924), 1, p. 76.
3. Ibid., p. 82.

Gustave Courbet

Ornans (near Besançon) 1819 – La Tour de Peilz (Switzerland) 1877

LA SOURCE DU LOUE, C. 1864 (PLATE 7).
(Source of the River Loue)

Gift of Walter Bareiss, B.S. 1940. Acc. No. 1956.31.1.

Oil on canvas; 921 x 813 mm. (36¼ x 32 in.).

Inscriptions: Signed at bottom right: *G. Courbet*.

Provenance: Ferdinand and Julien Tempelaere, Paris; Hector Brame, Paris (letter H. Brame, Paris, January 16, 1963); Richard Goetz, Paris; Walter Bareiss, New York.

Exhibitions: Probably Bremen, Kunsthalle, 1930; Paris, Seligmann, *Paysages de 1400 à 1900*, 1938, no. 103; San Francisco, *Golden Gate International Exposition*, 1939-40, *Art; Official Catalogue*, 1940, no. 252.

Bibliography: G. H. Hamilton, "Additions to the Modern Collection," *Bulletin*, Y.U.A.G., 23 (February, 1957), p. 13 [illustrated].

BORDS DU DOUBS; EFFET D'AUTOMNE, 1866 (PLATE 7).
(The Glen at Ornans)

Gift of Duncan Phillips, B.A. 1908. Acc. No. 1939.270.

Oil on canvas; 816 x 657 mm. (32⅛ x 25⅞ in.).

Inscriptions: Signed and dated at bottom left: . . 66 / *G. Courbet*.

Provenance: Henry Sayles, Boston (sale New York, Plaza Art Galleries, January 14-15, 1920, no. 126 [illustrated]); Knoedler, New York (*American Art Annual*, 17 (1920), p. 291); Kraushaar Gallery, New York; Duncan Phillips, Washington, D.C. (purchased from Kraushaar, 1921).

Exhibitions: Rochester, New York, Memorial Art Gallery, 1936-37.

Bibliography: D. Phillips, *A Collection in the Making* (Washington, D.C., 1926), p. 94, pl. 19.

CHASSEUR À CHEVAL, 1867 (PLATE 8).
(Hunter on Horseback)

Gift of J. Watson Webb, B.A. 1907, and Electra Havemeyer Webb. Acc. No. 1942.301.

Oil on canvas; 1189 x 965 mm. (46 13/16 x 38 in.).

Condition: The canvas is composed of two pieces joined horizontally together about 24 inches from the bottom.

Provenance: Atelier Courbet (sale Paris, Hôtel Drouot, June 28, 1882, no. 5: *Catalogue de tableaux, études, esquisses et dessins par Gustave Courbet dépendant de sa succession*. The painting was bought by an unknown bidder for 1,600 frs.); H. O. Havemeyer, New York; J. Watson Webb and Electra Havemeyer Webb, New York.

Exhibitions: Paris, *Exposition particulière*, 1867, no. 98 [as *Chasseur à cheval, retrouvant la piste, épisode de chasse à courre* (Ornans, 1867)]; Paris, Ecole des Beaux Arts, *Exposition des oeuvres de G. Courbet*, 1882, no. 151; New York, Metropolitan Museum, *Loan Exhibition of the Works of G. Courbet*, 1919, no. 26 [illustrated].

Bibliography: A. Estignard, *G. Courbet, sa vie et son oeuvre* (Besançon, 1897), p. 188; G. Riat, *G. Courbet, peintre* (Paris, 1906), pp. 246, 254; C. Léger, *Courbet* (Paris, 1929), pp. 122, 128, 216-17 (includes catalogue of the *Exposition particulière*, 1867, and catalogue of the sale, Paris, Hôtel Drouot, June 28, 1882); P. Courthion, *Courbet* (Paris, 1931), p. 84 (includes catalogue, 1867); *H. O. Havemeyer Collection, Catalogue of Paintings, Prints, Sculpture and Objects of Art* (New York, 1931), p. 351 [illustrated]; G. H. Hamilton, "The Webb Gift," *Bulletin*, Y.U.A.G., 12 (June, 1943), p. 4, no. 11 [illustrated]; C. Léger, *Courbet et son temps; lettres et documents inédits* (Paris, 1948), p. 110; W. M. Kane, "*Courbet's Chasseur of 1866-67*," *Bulletin*, Y.U.A.G., 25 (March, 1960), pp. 30-38 [illustrated]; L. W. Havemeyer, *Sixteen to Sixty, Memoirs of a Collector* (New York, 1961), p. 195.

According to the catalogue of Courbet's *Exposition particulière* (1867), *Hunter on Horseback* was painted during the winter of 1867 in Ornans, where the artist stayed from late October 1866 to mid-March 1867 and worked hard for his one-man show. While all the Barbizon painters exhibited at the Paris *Exposition universelle* (1867), Courbet had his own pavilion with 120 paintings at the Pont de L'Alma, like the young Manet, who also had set up his own one-man show in competition with the official exhibition.

During the nineteenth century, caricatures were a favored means of art criticism in France to ridicule individual artists or art movements of a particular style, like romanticism contra classicism. Manet's *Jeune femme couchée en costume espagnol* and Courbet's *Chasseur à cheval* and many of his other paintings have been caricatured. G. Randon's *Le Cheval du piqueur* appeared in *Le Journal amusant* (1867) as one in a series of caricatures on Courbet's *Exposition particulière*.[1]

The hypothesis that the hunter is the artist himself was first advanced in the Metropolitan Museum of Art's catalogue (1919) and then accepted in the Havemeyer Collection catalogue and later by W. M. Kane.[2] There are no earlier sources or other documents to support this thesis. Compared to other self-portraits, the hunter hardly seems to be Courbet himself.

1. Reproduced with many other caricatures on the *Exposition Courbet* in C. Léger, *Courbet selon les caricatures et les images* (Paris, 1920), p. 73, no. 25403.
2. W. M. Kane, *Bulletin*, Y.U.A.G. (March, 1960), pp. 30-38.

Edgar Hilaire Germain Degas
Paris 1834 – 1917

JOCKEYS, C. 1881-85 (PLATE 16).

Gift of J. Watson Webb, B.A. 1907, and Electra Havemeyer Webb. Acc. No. 1942.302.

Oil on canvas, mounted on cardboard; 264 x 399 mm. (10⅜ x 15 11/16 in.).

Inscriptions: Signed at bottom left: *Degas*; red wax seal on reverse: *Durand-Ruel*.

Provenance: H. O. Havemeyer, New York; J. Watson Webb and Electra Havemeyer Webb, New York.

Exhibitions: New York, Wildenstein, *A Loan Exhibition of Degas*, 1949, no. 62; South Hadley, Mass., Mount Holyoke College, 1956.

Bibliography: *H. O. Havemeyer Collection, Catalogue of Paintings, Prints, Sculpture and Objects of Art* (New York, 1931), p. 379; G. H. Hamilton, "The Webb Gift," *Bulletin*, Y.U.A.G., 12 (June, 1943), pp. 4-5 [illustrated]; E. A. Jewell, *French Impressionists and Their Contemporaries Represented in American Collections* (New York, 1944), p. 188 [illustrated]; P. Lemoisne, *Degas et son oeuvre* (4 vols. Paris, 1946-49), *1*, p. 122, *2*, p. 380, no. 680 [illustrated]; R. Cogniat, *Degas* (New York, 1948), p. 40 [illustrated]; H. Dumont, *Degas* (New York, Paris, London, 1948), p. 40 [illustrated]; D. C. Rich, *Degas* (New York, 1951), p. 96 [illustrated]; R. Huyghe, *Degas* (Paris, 1953), p. 24; D. C. Rich, *Degas* (New York,

1953), pl. 24; E. Huettinger, *Degas* (New York, 1960), pl. 47; L. W. Havemeyer, *Sixteen to Sixty, Memoirs of a Collector* (New York, 1961), p. 257.

The race is one of Degas' favorite subjects, and his earliest sketches of race horses date back to 1860-61. The composition of *Jockeys*, producing the effect of a snapshot, testifies to Degas' interest in photography. He himself was a very good photographer,[1] and he probably studied Major Muybridge's action photographs,[2] which revealed to him the range of movement in galloping horses.[3] *Jockeys* was probably painted after the publication of Muybridge's photographs, about 1881-85.

1. Cf. "Degas, photographe amateur, huit lettres inédites," *Gazette des Beaux-Arts*, 6. période, *61* (1963), pp. 61-64.
2. The photographs were reproduced in *La Nature* (Paris, December 14, 1878) and later in *The Globe* (September 27, 1881).
3. Cf. P. Cabanne, *Edgar Degas* (Paris and New York, 1958), pp. 27 ff. and A. Scharf, "Painting, Photography, and the Image of Movement," *Burlington Magazine*, *104* (May, 1962), pp. 186-95.

LA SALLE DE DANSE, C. 1891 (PLATE 17).
(Ballet Rehearsal)

Gift of Duncan Phillips, B.A. 1908. Acc. No. 1952.43.1.

Oil on canvas; 362 x 876 mm. (14⅛ x 34½ in.).

Inscriptions: Signed at bottom left: *Degas*.

Condition: Remains of black squaring on the floor in the left foreground. Correction of the exercising dancer on the right: see detail photograph in *Bulletin*, Y.U.A.G., *20* (March, 1953).

Provenance: Galerie Camentron, Paris; Durand-Ruel, Paris (bought from Camentron in 1897); Durand-Ruel, New York (from 1901); Clarke, New York; Durand-Ruel, New York (above provenance according to Durand-Ruel, letter, March 22, 1963); Duncan Phillips, Washington, D.C. (bought in 1928 from Durand-Ruel).

Preparatory studies: See *Catalogue des tableaux, pastels et dessins par E. Degas et provenant de son atelier* (4 vols. Paris, Galerie Georges Petit, 1918):
Second Sale Degas: nos. 217[1,2], 218[2], 220[2].

Third Sale Degas: nos. 88[1], 109[4], 112[4], 124[1], 138[4], 148[2], 361[1].
Fourth Sale Degas: no. 160[1].
H. Rivière, *Les Dessins de Degas* (Paris, 1924), no. 34.

Exhibitions: Probably Paris, Paul Rosenberg, *Exposition d'oeuvres de grands maîtres du XIXe siècle*, 1922, no. 37 [as *Danseuses au foyer*, 1885]; New Haven, Y.U.A.G., *French Paintings of the Nineteenth Century*, 1937, no. 6; Colorado Springs, Colo., Fine Arts Center, 1942-44; New York, Wildenstein, *A Loan Exhibition of Degas*, 1949, no. 79 [illustrated]; Pittsburgh, Carnegie Institute, *French Painting, 1100-1900*, 1951, no. 116 [illustrated]; Cambridge, Mass., Fogg Art Museum, *Degas' Dancers*, 1957; Los Angeles, County Museum, *An Exhibition of Works by E. Degas*, 1958, no. 60; Baltimore, Museum of Art, *Paintings, Drawings and Graphic Works by Manet, Degas, B. Morisot and M. Cassatt*, 1962, no. 50 [illustrated].

Bibliography: P. Lafond, *Degas* (Paris, 1918-19), *1*, p. 85 [illustrated; as *Salle d'exercices de danse*]; J. Meier-Graefe, *Degas* (Munich, 1920), pl. 52; G. Janneau, "Les grandes expositions. Maîtres du siècle passé," *La Renaissance de l'Art Français*, *5* (1922), pp. 336, 344 [illustrated] (summary of the exhibition at Rosenberg); J. B. Manson, *The Life and Work of Edgar Degas* (London, 1927), p. 49; D. Phillips, *The Artist Sees Differently* (New York and Washington, D.C., [1931]), *2*, pl. XLII; *L'Amour de l'Art*, *12*, Degas, special number (July, 1931), p. 280 [illustrated]; P. Lemoisne, *Degas et son oeuvre* (4 vols. Paris, 1946-49), *3*, p. 640, no. 1107 [illustrated]; L. Browse, *Degas Dancers* (London, 1949), p. 376, no. 114 [illustrated]; *Catalogue, The Phillips Collection* (Washington, D.C., 1952), p. 26, pl. 58; E. Gutsche, "The Ballet Rehearsal," *Bulletin*, Y.U.A.G., *20* (March, 1953), pp. 1-2 [illustrated]; "Recent Important Acquisitions of American Collections," *Art Quarterly*, *16* (1953), pp. 366-69 [illustrated].

Two similar versions of the painting are reproduced in Lemoisne: *La Leçon de danse*, no. 820, in the Courtauld Collection, London, and *Le Foyer de la danse*, no. 941, from the Joseph Widener Collection, now in the National Gallery of Art, Washington, D.C. The relation between these compositions and the Yale picture has been discussed thoroughly by E. Gutsche.[1]

1. Gutsche, *Bulletin*, Y.U.A.G. (March, 1953), pp. 1-2.

Maurice Denis

Granville 1870 – Paris 1943

ANNONCIATION MARIE, 1907 (PLATE 26).
(Annunciation)

Gift of Mr. and Mrs. Walter Bareiss, B.S. 1940. Acc. No. 1947.187.

Oil on wood panel; 330 x 489 mm. (13 x 19¼ in.).

Inscriptions: Signed and dated at the bottom right: MAU.D. *07*.

Provenance: Probably Galerie Druet, Paris (label on reverse of panel); Mr. and Mrs. Walter Bareiss, New York.

Bibliography: "Accessions 1946-47," *Bulletin*, Y.U.A.G., *15* (July, 1947), p. 2.

In 1907 Denis travelled to Italy where he painted several *Annunciations,* apparently on the terrace of his villa, Bella Vista, which he had rented in Fiesole.[1] The Yale composition, showing the light figures of Mary and the angel in a sunlit garden with dark green cypresses in the background, probably belongs to this group.

1. S. Barazzetti-Demoulin, *Maurice Denis* (Paris, c. 1945), pp. 66, 207 ff.

André Derain

Chatou 1880 – Chambourcy 1954

ROUTE DU MIDI, C. 1920-25 (PLATE 37).
(Street in the South)

Gift of Mrs. Leland Hayward. Acc. No. 1962.61.1.

Oil on canvas; 321 x 616 mm. (12⅝ x 24¼ in.).

Inscriptions: Signed at bottom right: *Derain*.

Provenance: Probably Paul Guillaume, Paris (Neugass, 1928-29); Mrs. Leland Hayward, New York (bought in London during the Second World War).

Bibliography: F. Neugass, "André Derain," *Die Kunst, 59* (1928-29), pp. 177-184 [illustrated]; "Recent Gifts and Purchases," *Bulletin,* Y.U.A.G., *29* (April, 1963), p. 32 [illustrated].

André Derain and Pablo Picasso

FOUR TILES WITH STILL LIFES, C. 1914 (PLATE 26).

The Philip L. Goodwin Collection, B.A. 1907. Acc. No. 1958.17a-d.

Oil on four ceramic tiles mounted in plaster; 527 x 527 mm. (20¾ x 20¾ in.), (with frame).

Inscriptions: Bottom left tile: *A. Derain;* Top right tile: SOUVENIR (last three letters in mirror writing).

Provenance: Galerie Léonce Rosenberg, Paris (sale Amsterdam, October 19, 1921, no. 123); Probably Galerie Simon, Paris (according to Zervos, 1942); Buchholz Gallery, New York; Philip L. Goodwin, New York (bought from Buchholz Gallery in 1940).

Bibliography: C. Zervos, *Pablo Picasso* (Paris, 1942), *2,* no. 493, pl. 227; "Recent Gifts and Purchases," *Bulletin,* Y.U.A.G., *24-25* (April, 1959), p. 50.

Derain, who had become a good friend of Picasso in 1906, spent the summer of 1914 with Picasso in Montfavet, near Avignon. It might well have been here that the two artists painted the four tiles. According to style and sources,[1] the two left tiles were painted by Picasso, the right ones by Derain. The left tiles are typical examples of Picasso's still lifes of that period, and those by Derain show the firm, realistic style that he developed after 1909.

1. Sale Catalogue of *L'Effort Moderne* (1921), no. 123.

Raoul Dufy

Le Havre 1877 – Forcalquier (Basses-Alpes) 1953

LE MODÈLE HINDOU, C. 1929 (PLATE 40).
(The Hindu Model)

Gift of Walter Bareiss, B.S. 1940. Acc. No. 1954.43.3.

Oil on canvas; 368 x 451 mm. (14½ x 17¾ in.).

Inscriptions: Signed at bottom left: *Raoul Dufy.*

Provenance: Mac Donald (according to Berr de Turique, 1930); Bignou Gallery, New York; Walter Bareiss, New York (bought from Bignou Gallery about 1942-43).

Exhibitions: New York, Bignou Gallery, *Dufy and Some of His Contemporaries,* 1943, no. 4; Athens, Georgia, University of Georgia, Department of Art, 1957.

Bibliography: M. Berr de Turique, *Raoul Dufy* (Paris, 1930), p. 12 [illustrated]; *Colour, 2* (January, 1930), p. 24 [illustrated], "Accessions 1954," *Bulletin,* Y.U.A.G., *21* (March, 1955), p. 11.

Dufy's trip to Morocco in 1925 might have inspired his series of Hindu Models, which he painted during the end of the twenties and beginning thirties. They owe much to Matisse's *Odalisques* of the same period. Several other versions of *Le Modèle hindou,* both paintings and drawings, were done during the period 1928-31.[1]

1. Cf. Berr de Turique, *Dufy* (1930), pp. 7, 12, 133, 135, 249, 250; B. Dorival, *Raoul Dufy* (Paris, Musée National d'Art Moderne, 1953), nos. 50, 58. Another version is *Nude Reclining*, Washington, D.C., National Gallery of Art.

School of Fontainebleau

LE CONCERT, AFTER 1556 (PLATE 1).
(The Art of Music)

The Louis M. Rabinowitz Collection. Acc. No. 1959.15.25.

Oil on wood panel; 930 x 892 mm. (36⅝ x 35 1/16 in.).

Condition: The painting was cleaned in 1959. It is unfinished and shows black chalk drawing underlying various parts.

Provenance: E. and A. Silberman, New York [as by Primaticcio, under title *Expulsion of Avarice,* according to label on reverse of painting]; Louis M. Rabinowitz, Sands Point, Long Island, New York.

Exhibitions: West Palm Beach, Florida, Norton Gallery and School of Art, 1942; Williamstown, Mass., Williams College, Museum of Art, 1942; New Haven, Y.U.A.G., *Pictures Collected by Yale Alumni,* 1956, no. 6 [illustrated].

Bibliography: L. Venturi, *The Rabinowitz Collection* (New York, 1945), pp. 71-72 [illustrated]; C. Sterling, *De Triomf van het Maniërisme* (Amsterdam, Rijksmuseum, 1955), p. 73 [as by the Maître de Flore]; C. Seymour, Jr., *The Rabinowitz Collection of European Paintings* (New Haven, Y.U.A.G., 1961), pp. 44-45 [illustrated].

This painting depicts, with deviations, the right part of the frescoed lunette, above the musicians' gallery, in the *Salle de bal* at Fontainebleau, which Primaticcio painted with the cooperation of Niccolò dell'Abbate during the period of 1552-1556.[1] The scene at the Salle de bal is also the subject of a painting in the Louvre, which is attributed to a follower of Primaticcio and more recently by S. Béguin to the Maître de Flore.[2]

While the Louvre painting is very close to the fresco, the Yale version shows various changes, which indicate that the artist probably never saw the fresco in its original context and that he did not understand its meaning. C. Sterling attributed the Yale painting to the Maître de Flore,[3] but design and color, and particularly the comparison to the painting in the Louvre, make a northern, perhaps Flemish artist, much more likely. A Flemish painter had already been proposed by C. Seymour, Jr.[4]

The same scene has been engraved by Alexandre Bettou (1607-1693) in the series that he made after the frescoes in the Salle de bal.[5]

1. L. Dimier, *Le Primatice* (Paris, 1900), p. 454, no. 159, was the first to recognize a drawing, now in the Albertina, as the original preparatory study for the right section of this lunette. Cf. also *Parmegianino und sein Kreis* (Vienna, Albertina, 1963), no. 180.
2. S. Béguin, *L'Ecole de Fontainebleau* (Paris, 1960), p. 77.
3. C. Sterling, *De Triomf van het Maniërisme* (1955), p. 73.
4. C. Seymour, Jr., *The Rabinowitz Collection* (1961), pp. 44-45.
5. R. Dumesnil, *Le Peintre graveur français, 8* (Paris, 1850), pp. 227-28, no. 1.

Eugène Fromentin
La Rochelle 1820 – St. Maurice 1876

ARABIAN ENCAMPMENT, 1847 (PLATE 10).

Bequest of Blanche Barclay for the George C. Barclay Collection. Acc. No. 1949.236.

Oil on canvas; 740 x 390 mm. (29¼ x 15¾ in.).

Inscriptions: Signed and dated at the bottom right: *E. Fromentin 47.*

Provenance: George C. Barclay, New York.

Bibliography: "Accessions 1949-1950," *Bulletin*, Y.U.A.G., *19* (January, 1951).

Claude Gellée, *called Claude le Lorrain*
Chamagne, near Mirecourt (Vosges) 1600 – Rome 1682

PASTORAL LANDSCAPE, 1648 (PLATE 2).

Leonard C. Hanna, Jr., B.A. 1913, Fund. Acc. No. 1959.47.

Oil on copper; 405 x 550 mm. (15⅞ x 21⅝ in.).

Provenance: Georg Werdmüller, Zurich [executed for him in 1648 (Liber Veritatis 116)]; Thomas Barrett, Lee Priory, near Canterbury (bought.during the first half of the 18th century); Barrett-Brydges family [by descent] (sale, London, Christie, May 28, 1859, no. 147 [as *Sunset*, to Norton, dealer]); Sir Frederick Cook [by 1902], thence by descent (sale, London, Sotheby, June 25, 1958, no. 55); Newhouse Galleries, New York.

Exhibitions: London, Royal Academy of Arts, *Exhibition of Works by Old Masters*, winter 1902, no. 69.

Bibliography: Lee Priory Catalogue of 1817 [?], no. 8; J. Smith, *A Catalogue Raisonné of the Works of the Most Eminent Dutch, Flemish, and French Painters. . . .* (London, 1837), p. 254, no. 116; [M. F. Sweetser], *Claude Lorrain* (Boston [c. 1887]), p. 146; M. Pattison, *Claude Lorrain, sa vie et ses oeuvres, d'après des documents inédits* (Paris, 1884), p. 60, no. 116, p. 190 [with errors], p. 217; O. J. Dullea, *Claude Gellée* (New York, 1887), p. 47, p. 111 [with errors]; H. Cook, ed., *A Catalogue of the Paintings at Doughty House, Richmond* (London, 1915), *3*, no. 446 [with incorrect reference to LV 160]; H. Cook ed., *Abridged Catalogue of the Pictures at Doughty House* (London, 1932); M. Roethlisberger, "New Light on Claude Lorrain," *Connoisseur*, 144-45 (1960), pp. 59-61 [illustrated]; "Recent Gifts and Purchases," *Bulletin*, Y.U.A.G., *26* (December, 1960), p. 14 [illustrated]; M. Roethlisberger, *Claude Lorrain, The Paintings, Critical Catalogue* (2 vols. New Haven, 1961), *1*, pp. 290-91, *2*, pl. 204; "Nouvelles acquisitions des musées durant l'année 1960," *Gazettes des Beaux Arts*, 6. période, *57*, Supplement 24 (1961), p. 24 [illustrated].

Liber Veritatis 116 is a drawing on white paper, inscribed on the reverse: *Claudio Gillee Roma 1648 v. | faict pour il sig. verdon* [for Verdommiller; rest cut off]. The painting was executed for Hans Georg Werdmüller, a military engineer and collector from Zurich, who went to Venice in 1650. Since he did not go to Rome, it is not clear how he got in touch with Claude. Paintings and drawings related to the *Pastoral Landscape* are discussed by Roethlisberger (1961): "The composition is based on nos. 107 and 211, adapted to the small size;" cf. also nos. 103, 117, 124 and for the figures in the foreground drawing 115. The painting is Claude's last large copper.

Albert Gleizes
Paris 1881 – 1953

PAYSAGE, 1914 (PLATE 27).

Collection of the Société Anonyme. Acc. No. 1941.485.

Oil on canvas; 733 x 923 mm. (28⅞ x 36⅜ in.).

Inscriptions: Signed and dated at bottom left: *Alb Gleizes 1914.* Signed in faded crayon in the hand of the artist (?) on reverse: *A Gleizes.*

Provenance: Wanamaker Galleries, New York; Collection of the Société Anonyme, New York (bought in New York in 1930).

Exhibitions: New Haven, Y.U.A.G., *Exhibition Inaugurating the Collection of the Société Anonyme*, 1942, no. 40; Middletown, Conn., Wesleyan University, *Special Exhibition of the Collection of the Société Anonyme*, 1942; Travelling Exhibition: *Modern Art from the Collection of the Société Anonyme*, 1945-46; Minneapolis, The Walker Art Center, *The Classic Tradition in Contemporary Art*, 1953, no. 47; Hartford, Conn., Wadsworth Atheneum, *Paintings by Artists of the Collection of the Société Anonyme*, 1959; Baltimore, Md., Museum of Art, *1914*, 1964, no. 74.

Bibliography: G. H. Hamilton, "The Exhibition of the Collection of the Société Anonyme-Museum of Modern Art: 1920," *Bulletin*, Y.U.A.G., 10 (December, 1941), p. 3; K. S. Dreier and M. Duchamp, *Collection of the Société Anonyme: Museum of Modern Art 1920* (New Haven, 1950), pp. 145-46 [illustrated]; A. T. Schoener, "Gleizes," *The Cincinnati Art Museum Bulletin*, 4 (March, 1956), pp. 18-22 [illustrated].

Vincent van Gogh
Groot-Zundert 1853 – Auvers-sur-Oise 1890

COIN DE PARC, C. 1886-87 (PLATE 19).
(Corner of the Park)

Gift of Henry R. Luce, B.A. 1920. Acc. No. 1958.59.

Oil on canvas; 593 x 812 mm. (23⅜ x 32 in.).

Condition: The painting has been relined.

Provenance: V. W. van Gogh, Amsterdam (until 1928, according to the Stedelijk Museum, Amsterdam, letter, December 5, 1962); Private Collection, Scotland; Lefevre Gallery, London; Sam Salz, Inc., New York; Henry R. Luce, New York.

Exhibitions: Amsterdam, Stedelijk Museum, 1905, no. 65; Berlin, Paul Cassirer, *Vincent van Gogh*, 1914, no. 61 [as *Park in Asnières*, 1888]; Aberdeen, Art Gallery, Festival Exhibition, *Pictures from Northern Homes*, 1951, no. 145; New Haven, Y.U.A.G., *Paintings, Drawings and Sculpture Collected by Yale Alumni*, 1956, no. 98 [illustrated].

Bibliography: J. B. de La Faille, *L'Œuvre de Vincent van Gogh, catalogue raisonné* (4 vols. Paris and Brussels, 1928), 1, p. 81, no. 276 [illustrated]; J. B. de La Faille, *Vincent van Gogh* (Paris, 1939), p. 261, no. 353 [illustrated]; "Recent Gifts and Purchases," *Bulletin*, Y.U.A.G., 24-25, (April, 1959), pp. 29, 50 [illustrated].

Vincent van Gogh came to Paris in February 1886, where he stayed with his brother Theo until he left the city in February 1888 to go to Arles. The technique and color of *Coin de parc* show the influence of the pointillists and suggest a date late in 1886 or in the early summer of 1887. The picture was probably painted between the *Interior of a Restaurant*[1] and the many landscapes of the following summer. *View in the Park* and *The Park of Asnières*[2] are two other park scenes of the same period, which are closely related in style and subject to *Coin de parc*.

1. De La Faille, *Van Gogh* (1928), no. 342. Usually dated autumn-winter 1886.
2. Ibid., nos. 275, 314.

LE CAFÉ DE NUIT, 1888 (FRONTISPIECE).
(Night Café)

Bequest of Stephen C. Clark, B.A. 1903. Acc. No. 1961.18.34.

Oil on canvas; 724 x 921 mm. (28½ x 36¼ in.).

Inscriptions: Signed at bottom right: *Vincent / le café de nuit.*

Provenance: Mme. J. van Gogh-Bonger, Amsterdam; J. A. Morosov, Moscow (acquired at the *Exhibition of the Golden Fleece*, Moscow, 1908); Museum of Modern Art, Moscow; Stephen C. Clark, New York.

Exhibitions: Amsterdam, Stedelijk Museum, 1905, no. 133; Moscow, *Exhibition of the Golden Fleece*, 1908; Moscow, Museum of Modern Art, 1928, no. 81, pl. III; New York, Museum of Modern Art, *5th Anniversary Exhibition*, 1934/35, no. 34 [illustrated]; Chicago, Art Institute, *Century of Progress Exhibition*, 1934, no. 312, pl. XLVII; New York, Museum of Modern Art, *The Work of Vincent van Gogh*, 1935-36, no. 34 [illustrated]; Chicago, The Arts Club, *Origins of Modern Art*, 1940, no. 32; New York, Paul Rosenberg, *Eleven Paintings of Vincent van Gogh*, 1942, no. 1; New York,

Wildenstein, *The Art and Life of Vincent van Gogh*, 1943, no. 32; New York, Knoedler, *Fourteen Masterpieces of van Gogh*, 1948, no. 6 [illustrated]; Cleveland, Museum of Art, *The Work of Vincent van Gogh*, 1948, no. 11, pl. ix; New York, Metropolitan Museum, *Van Gogh, Paintings and Drawings: a Special Loan Exhibition*, 1949-50, no. 80A [illustrated] (also at Chicago, Art Institute); New York, Knoedler, *A Collector's Taste*, 1954, no. 18 [illustrated]; New York, Museum of Modern Art, *Paintings from Private Collections*, 1955, p. 10; New Haven, y.u.a.g., *Paintings, Drawings and Sculpture Collected by Yale Alumni*, 1960, no. 70 [illustrated].

Bibliography: *Zolotoe Runo* (Moscow), 2, nos. 7-9 [illustrated opposite p. 58; an account of the *Golden Fleece* exhibition; already listed as the property of I. A. Morozov]; *Van Gogh-Mappe* (Munich, 1912), no. 6; *Apollon* (1912), nos. 3-4 [illustrated] (an account of the Morozov Collection); A. J. Eddy, *Cubists and Post-Impressionsim* (Chicago, 1914) [illustrated opposite p. 56]; "Les grands collectionneurs, iii, M. Ivan Morosoff," *Bulletin de la Vie Artistique*, 1 (May 15, 1920), p. 330 [illustrated]; G. Coquiot, *Vincent van Gogh* (Paris, 1923), p. 160 [illustrated]; B. N. Ternovets, "Le Musée d'Art Moderne de Moscou," *L'Amour de l'Art* (December, 1925), p. 474; J. B. de La Faille, *L'Œuvre de Vincent van Gogh, catalogue raisonné* (4 vols. Paris and Brussels, 1928), *1*, p. 131, no. 463; F. Fels, *Vincent van Gogh* (Paris, 1928), p. 160 [illustrated]; F. Knapp, *Vincent van Gogh* Bielefeld and Leipzig, 1930), p. 55, pl. 32; H. A. Bull, Jr., "Modern French Paintings in Moscow," *International Studio*, 97 (October, 1930), p. 25; Becker, "The Museum of Modern Western Painting," *Creative Art*, 10 (March, 1932), p. 199; J. Meier-Graefe, *Vincent van Gogh* (New York, 1933), pl. 26; B. N. Ternovets, *Modern French Colorplates* (Moscow, Museum of Modern Western Art, 1933), no. 2; C. Terrasse, *Vincent van Gogh peintre* (Paris, 1935) [illustrated between pp. 116-21]; L. Vitali, *Vincent van Gogh*, Arte moderna straniera, 6 (Milan, 1936), pl. x; L. Piérard, *Vincent van Gogh* (Paris, 1936), fig. 33; W. Pach, *Vincent van Gogh* (New York, 1936), pl. 29; W. Scherjon and J. de Gruyter, *Vincent van Gogh's Great Period: Arles, St. Rémy and Auvers-sur-Oise* (Amsterdam, 1937), pp. 108-09, no. 83 [illustrated]; C. Zervos, *Histoire de l'art contemporain* (Paris, 1938), p. 90 [illustrated]; J. B. de La Faille, *Vincent van Gogh* (Paris, 1939), p. 350, pl. 491; M. Rosset, *Vincent van Gogh* (Paris, 1941), pl. 74; A. Parronchi, *Vincent van Gogh* (Florence,

1944), fig. 17; E. A. Jewell, *French Impressionists and Their Contemporaries Represented in American Collections* (New York, 1944), p. 186 [illustrated]; E. A. Jewell, *Vincent van Gogh* (New York, 1946), p. 32 [illustrated]; L. Hautecoeur, *Vincent van Gogh* (Monaco and Geneva, 1946), pl. 72; [P. Courthion], *Vincent van Gogh, raconté par lui-même et par ses amis* (Geneva, 1947) [illustrated opposite p. 112]; G. Schmidt, *Vincent van Gogh* (Berne, 1947), p. 24, fig. 30; *Cahiers d'Art*, 22 (1947), pp. 159-266 [illustrated] (contributions on the occasion of the van Gogh exhibition in Paris, 1947); R. Cogniat, *French Paintings at the Time of the Impressionists* (New York, Paris and London, 1950), p. 113 [illustrated]; J. Seznec, "Literary Inspiration in van Gogh," *Magazine of Art*, 43 (1950), p. 286 [illustrated]; J. Leymarie, *Vincent van Gogh* [Paris, 1951], no. 96 [illustrated]; M. Schapiro, *Vincent van Gogh* (New York, 1951), p. 70 [illustrated]; W. Weisbach, *Vincent van Gogh* (2 vols. Basel, 1951), *2*, pp. 81-85, pl. 44; J. de Laprade, *Vincent van Gogh* (Paris, 1951), pl. 50; C. Nordenfalk, *The Life and Work of Vincent van Gogh* (London, 1953), p. 148, fig. 45; C. Estienne, *Vincent van Gogh* (Geneva, 1953), p. 63 [illustrated]; Valsecchi, *Vincent van Gogh* (Milan, 1954), pl. 36; J. Rewald, *Post-Impressionism from van Gogh to Gauguin* (New York, 1956), pp. 233-34 [illustrated]; J. Vinchon, "Les Hommes et paysages de Vincent van Gogh," *Aesculape* (March, 1957), p. 29 [illustrated]; F. Elgar, *Vincent van Gogh* (New York, 1958), no. 138 [illustrated]; R. Hughe, *Vincent van Gogh* (New York, 1958), p. 61 [illustrated]; K. Badt, *Die Farbenlehre Vincent van Goghs* (Cologne, 1961), pp. 125, 126, 128, pl. 19; "Accessions of American and Canadian Museums," *Art Quarterly*, 24 (1961), p. 400 [illustrated]; "Yale Exhibits Clark Bequest," *Art Journal*, 21 (1961-62), p. 118 [illustrated]; "La Chronique des Arts" in *Gazette des Beaux Arts*, 6. période, 59 (February, 1962), p. 47, no. 157 [illustrated]; "Recent Gifts and Purchases," *Bulletin*, y.u.a.g., 28 (December, 1962), p. 48 [illustrated on cover].

Van Gogh wrote about the evolution and symbolic meaning of his *Café de nuit* (the café de l'Alcazar, place Lamartine in Arles) in several of his letters to Theo and to his friend Emile Bernard.[1] According to these letters Vincent painted the *Night Café* in August and September 1888. It was one of the cafés that stayed open all night, and Van Gogh used to spend the

evening there "by gaslight." It was a place where "night prowlers can take refuge . . . when they have no money to pay for a lodging."[2] "Then to the great joy of the landlord, of the postman whom I had already painted, of the visiting night prowlers and of myself, for three nights running I sat up to paint and went to bed during the day. I often think that the night is more alive and more richly colored than the day."[3] The dominating colors, red, green, and yellow, had a deep symbolic meaning for him; he continues in his letter: "It is the equivalent, though different, of the 'Potato Eaters.' I have tried to express the terrible passions of humanity by means of red and green. The room is blood red and dark yellow with a green billiard table in the middle; there are four citron-yellow lamps with a glow of orange and green. Everywhere there is a clash and contrast of the most disparate reds and greens in the figures of little sleeping hooligans, in the empty, dreary room, in violet and blue."[4]

The watercolor of the *Café de nuit* (now in the Hahnloser Collection, Winterthur, Switzerland) was done after the painting; Van Gogh made it to send to Theo in order to give his brother some idea of the painting that preoccupied him so much: "In my picture of the *Night Café* I have tried to express the idea that the café is a place where one can ruin oneself, go mad or commit a crime. So I have tried to express, as it were, the powers of darkness in a low public house, by soft Louis XV green and malachite, contrasting with yellow-green and harsh blue-greens, and all this is an atmosphere like a devil's furnace, of pale sulphur. And all with an appearance of Japanese gaiety, and the good nature of Tartarin. But what would Monsieur Tersteeg say about this picture when he said before a Sisley – Sisley, the most discreet and gentle of the impressionists – 'I can't help thinking that the artist who painted that was a little tipsy'. If he saw my picture, he would say that it was delirium tremens in full swing."[5]

1. *The Complete Letters of Vincent van Gogh*, (3 vols., Greenwich, Conn., 1958), 3, nos. 518, 533, 534, 539, 605; xv-xvii.

2. Ibid., no. 518.
3. Ibid., no. 533.
4. Ibid., no. 533.
5. Ibid., no. 534.

Juan Gris (José Gonzales)
Madrid 1887 – Boulogne-sur-Seine 1927

ABSTRACTION NO. 2: LE JOURNAL, 1916
(PLATE 28).

Collection of the Société Anonyme. Acc. No. 1941.489.

Oil on canvas; 921 x 597 mm. (36¼ x 23½ in.).

Inscriptions: Signed on the reverse at the top left: *Juan Gris / 3 – 16 / 2e.*

Provenance: Léonce Rosenberg, Paris; Collection of the Société Anonyme, New York (bought from Léonce Rosenberg in 1927).

Exhibitions: New York, Brooklyn Museum, *An International Exhibition of Modern Art Assembled by the Société Anonyme*, 1926-27, no. 207; New York, Marie Harriman Gallery, *Juan Gris*, 1932, no. 13; Springfield, Mass., Museum of Fine Arts, *French Paintings: Cézanne to the Present*, 1935-36, no. 17; Springfield, Mass., The George Walter Vincent Smith Art Gallery, *Some New Forms of Beauty, 1909-1936, A Selection of the Collection of the Société Anonyme*, 1939, no. 19; New Haven, Y.U.A.G., *Exhibition Inaugurating the Collection of the Société Anonyme*, 1942, no. 43; Middletown, Conn., Wesleyan University, *Special Exhibition of the Collection of the Société Anonyme*, 1942; Travelling Exhibitions 1945-46; 1946-47; Springfield, Mass., Museum of Fine Arts, *In Freedom's Search*, 1950, no. 26; Minneapolis, Minn., The Walker Art Center, *The Classic Tradition in Contemporary Art*, 1953, no. 49; Hartford, Conn., Wadsworth Atheneum, *Twentieth Century Painting from Three Cities, New York, New Haven and Hartford*, 1955, no. 21, pl. III.

Bibliography: G. H. Hamilton, "The Exhibition of the Collection of the Société Anonyme-Museum of Modern Art: 1920," *Bulletin*, Y.U.A.G., *10* (December, 1941), p. 5 [illustrated]; D. H. Kahnweiler, *Juan Gris, His Life and Work* (New York, 1947), no. 27 [illustrated; as *Newspaper and*

Fruit-Dish]; K. S. Dreier, J. J. Sweeney, and Naum Gabo, *Three Lectures on Modern Art* (New York, 1949), p. 53 [illustrated]; K. S. Dreier and M. Duchamp, *Collection of the Société Anonyme: Museum of Modern Art 1920* (New Haven, 1950), pp. 59-60 [illustrated].

The year of the two Yale paintings, 1916, marks the beginning of Gris' "architectural period," as Kahnweiler has called it. *Abstraction No. 2: Le Journal*, painted in March, still shows the multiple description of objects with predominating primary colors: blue and yellow on a vibrating surface with colored dots. The objects are densely speckled as those of some other still lifes of the same year and the previous one. Another version, *Still Life in Yellow and Blue*, (1916) (New York, The Solomon R. Guggenheim Museum), with a very similar composition, also has the speckled planes and the predominance of blue and yellow. The same "confetti-like stippling"[1] appeared in some of Picasso's and Braque's paintings of 1912-14, and was also used by Delaunay as early as 1910.[2]

1. A. H. Barr, *Picasso, Fifty Years of His Art* (New York, 1946), p. 83.
2. *The City No. 2*, Paris, Musée d'Art Moderne.

STILL LIFE, 1916 (PLATE 29).

Gift of Mr. and Mrs. Gilbert N. Chapman, B.S. 1924. Acc. No. 1962.39.

Oil on panel; 413 x 241 mm. (16¼ x 9½ in.).

Inscriptions: Signed at bottom right: *Juan Gris / 10 – 16*.

Provenance: Probably Léonce Rosenberg, Paris; Earl Horter, Chicago; Mrs. Gilbert N. Chapman, New York (acquired from the Horter Collection in 1934). (Letter Mrs. Chapman, New York, April 16, 1964).

Exhibitions: New York, Marie Harriman Gallery, *Juan Gris*, 1932, no. 9; Chicago, The Arts Club, *Exhibition of the Earl Horter Collection*, 1934; New York, Jacques Seligmann, *Juan Gris Retrospective Loan Exhibition*, 1938, no. 10 [illustrated]; Chicago, The Arts Club, *Retrospective Exhibition of Juan Gris*, 1939, no. 13; New York, Buchholz Gallery, *Juan Gris*, 1944, no. 11; New Haven, Y.U.A.G., *Pictures Collected by Yale Alumni*, 1956, no. 139 [illustrated].

Bibliography: "Recent Gifts and Purchases," *Bulletin*, Y.U.A.G., 29 (April, 1963), pp. 23, 43 [illustrated].

During the summer of 1916 Gris abandoned more and more the lively compositions based on primary colors and vibrating surfaces, and developed serene paintings with a somber color scheme in brown, gray, black, and white. The small *Still Life* of October 1916, when compared with *Abstraction No. 2: Le Journal*, painted in March of that same year, reveals the change that Gris' work underwent in only a few months.

Fernand Léger

Argentan (Orne) 1881 – Gif-sur-Yette 1955

COMPOSITION NO. 7, 1925 (PLATE 38).

Collection of the Société Anonyme. Acc. No. 1941.542.

Oil on canvas mounted on aluminum; 1305 x 894 mm. (51⅜ x 35 3/16 in.).

Inscriptions: Signed and dated at bottom right: F LEGER / 25.

Provenance: Léonce Rosenberg, Paris; Collection of the Société Anonyme, New York (bought from Léonce Rosenberg in 1926).

Exhibitions: New York, Brooklyn Museum, *An International Exhibition of Modern Art Assembled by the Société Anonyme*, 1926-27, no. 43 [illustrated]; New York, Anderson Galleries, *International Exhibition of Modern Art Assembled by the Société Anonyme*, 1927, no. 24 [illustrated]; New York, Museum of Modern Art, *Cubism and Abstract Art*, 1936, no. 134 [illustrated]; Springfield, Mass., The George Walter Vincent Smith Art Gallery, *Some New Forms of Beauty 1909-1936, A Selection of the Collection of the Société Anonyme: Museum of Modern Art 1920*, 1939, no. 34 [illustrated]; New Haven, Y.U.A.G., *Exhibition Inaugurating the Collection of the Société Anonyme*, 1942, no. 41; Travelling Exhibition 1945-46.

Bibliography: K. S. Dreier, *Catalogue of an International Exhibition of Modern Art Assembled by the Société Anonyme* [Brooklyn Museum] (New York, 1926), p. 15 [illustrated];

K. S. Dreier, "Explaining Modern Art," *The American Art Student*, 10 (March, 1927), pp. 46-47 [illustrated]; G. E. Lemaître, *From Cubism to Surrealism in French Literature* (Cambridge, Mass., 1941), pl. opposite p. 112; G. H. Hamilton, "The Exhibition of the Collection of the Société Anonyme-Museum of Modern Art: 1920," *Bulletin*, Y.U.A.G., 10 (December, 1941), p. 3; K. S. Dreier, J. J. Sweeney and Naum Gabo, *Three Lectures on Modern Art* (New York, 1949), p. 28 [illustrated]; K. S. Dreier and M. Duchamp, *Collection of the Société Anonyme: Museum of Modern Art 1920* (New Haven, 1950), pp. 152-53 [illustrated]; R. Rosenblum, *Cubism and 20th Century Art* (New York, 1960), pp. 145, 320, fig. 86.

Léger did not completely develop his motionless, static, and highly geometrical style until about 1924. The objects, sparingly used, are interlocked in flat planes; strong horizontals and verticals dominate the composition. This transformation was certainly related to the movement known as *"purisme,"* whose leaders were Le Corbusier and Amédée Ozenfant. In 1924, the year of his film *Le Ballet mécanique*, Léger founded with Ozenfant a studio, where they taught along with Marie Laurencin and Exter. How much Léger's compositions of the mid-twenties correspond to the pure, simple clarity of Le Corbusier's architecture is seen in their mutual creation of the pavilion *L'Esprit nouveau*, at the 1925 Paris *Exposition internationale des arts décoratifs*. *Composition No. 7* is one of the many still lifes of 1924-25 with the characteristic dominance of horizontals and verticals and the thin application of colors corresponding to the geometric purity of the composition.

LE VIADUC, 1925 (PLATE 39).
(The Viaduct)

The Philip L. Goodwin Collection, B.A. 1907. Acc. No. 1958.18.

Oil on canvas; 647 x 919 mm. (25½ x 36 3/16 in.).

Inscriptions: Signed and dated at bottom right: F. LEGER / 25; inscribed on reverse at top left, probably by the artist: *Le Viaduc* / *F. Léger* / 25.

Provenance: Léonce Rosenberg, Paris (according to label on reverse); Galerie Louis Carré, Paris (bought from Léonce Rosenberg in 1938; letter, Carré, Paris, May 8, 1964); Philip L. Goodwin, New York (bought from Carré in 1941).

Preparatory Studies: A pencil drawing for the painting, squared for transfer, is in the collection of Mrs. Robert L. Heilbroner, New York [reproduced in *Art News*, 50 (January, 1952), p. 44].

Bibliography: *Bulletin de l'Effort Moderne*, 1 (June, 1925) [illustrated]; W. George, "Fernand Léger," *The Arts*, 15 (1929), p. 309 [illustrated]; *Juan Gris-Fernand Léger*, Zurich, Kunsthaus (1933) [illustrated in the catalogue but not exhibited]; *Cahiers d'Art*, 8 (1933), 3-4, p. 119 [illustrated; same text as Zurich catalogue]; J. Bazaine, *Fernand Léger, peintures antérieures à 1940* (Paris, 1945), p. 37 [illustrated] (published on the occasion of the exhibition at the Galerie Louis Carré, 1945); P. Descargues, *Fernand Léger* (Paris, 1955), p. 84 [illustrated]; "Recent Gifts and Purchases," *Bulletin*, Y.U.A.G., 24-25 (April, 1959), pp. 32, 50 [illustrated].

The Viaduct is composed of the same structural elements found in the many still lifes of 1924-25. While Cézanne and Braque painted the viaduct as only a part of a specific landscape, Léger made it the dominating element: "the made object is there, absolute, polychrome, pure and exact, beautiful in itself; . . . I have never been amused to copy a machine. I invent images of machines like others do landscapes with imagination. The mechanical element is not a set purpose for me, or an attitude, but a way to give a sensation of strength and power."[1]

1. From the lecture "L'esthétique de la machine," delivered at the Collège de France in 1925. See F. Fels, *Propos d'artistes* (Paris, 1925), pp. 98 ff.

Edouard Manet
Paris 1832 – 1883

JEUNE FEMME COUCHÉE EN COSTUME ESPAGNOL, 1862-63 (PLATE 12).
(Young Woman Reclining, in Spanish Costume)

Bequest of Stephen C. Clark, B.A. 1903. Acc. No. 1961.18.33.

Oil on Canvas; 947 x 1137 mm. (37¼ x 44¾ in.).

Inscriptions: Inscribed and signed at the bottom right: *A mon ami Nadar / Manet.*

Provenance: Félix Tournachon, called "Nadar", Paris, to whom Manet presented the picture (sale, Nadar, Paris, Nov. 11-12, 1895, no. 60); Eduard Arnhold, Berlin; Stephen C. Clark, New York.

Exhibitions: Paris, Galerie Martinet, 1863, no. 130; Paris, *Exposition Manet*, Pont de l'Alma, 1867, no. 35; Paris, Ecole des Beaux Arts, *Exposition des oeuvres de E. Manet*, 1884, no. 20; Dresden, *Kunstausstellung* [probably *Internationale Kunstausstellung*, organized by the Künstlerbund], 1912; Berlin, Preussische Akademie der Kuenste, *Fruehjahrsausstellung*, 1926, no. 19 [as *Maja*]; New York, Knoedler, *A Collector's Taste*, 1954, no. 6 [illustrated]; New Haven, Y.U.A.G., *Pictures Collected by Yale Alumni*, 1956, no. 71 [illustrated].

Bibliography: L. Gonse, "Manet," *Gazette des Beaux Arts*, 2. période, 29 (1884), p. 140; E. Bazire, *Manet* (Paris, 1884), p. 54; T. Duret, *Histoire de Edouard Manet et de son oeuvre* (Paris, 1906), p. 54; J. Meier-Graefe, *Impressionisten* (Munich, 1907), p. 83; T. Duret, *Manet and French Impressionists* (London and Philadelphia, 1910), pp. 26, 217, no. 46; J. Meier-Graefe, *Edouard Manet* (Munich, 1912), pp. 57, 65 [illustrated]; A. Proust, *Edouard Manet: souvenirs* (Paris, 1913), pp. 53, 164; H. von Tschudi, *Edouard Manet* (4th ed. Berlin, 1920), pp. 14, 22 [illustrated]; J. E. Blanche, *Manet* (Paris, 1924), p. 35; E. Moreau-Nélaton, *Manet raconté par lui-même* (2 vols. Paris, 1926), *1*, pp. 44, 47, 51, 86, pl. 45; *2*, p. 127, no. 20, fig. 339; M. Dormoy, "La Collection Arnhold," *L'Amour de l'Art*, 7 (1926), p. 242 [illustrated]; T. Duret, *Histoire de Edouard Manet et de son oeuvre* (4th ed. Paris, 1926), pp. 39, 241, no. 46; P. Jamot, "Manet and the Olympia," *Burlington Magazine*, 50 (1927), pp. 27-32 [illustrated]; A. Flament, *La Vie de Manet* (Paris, 1928), p. 183; A. Tabarant, *Manet, histoire catalographique* (Paris, 1931), p. 86, no. 55; P. Jamot and G. Wildenstein, *Manet, catalogue critique* (2 vols. Paris, 1932), *1*, pp. 31, 33, 37, 76, 123, no. 63; *2*, pl. 319; D. C. Rich, "Spanish Background for Manet's Early Work," *Parnassus*, 4 (February, 1932), p. 4; E. Lambert, "Manet et l'Espagne," *Gazette des Beaux Arts*, 5. période 9 (1933), pp. 369, 373, 377 [illustrated]; T. Duret, *Manet* (New York, 1937), p. 32; R. Rey, *Manet* (London and Toronto, 1938), p.

12; G. Jedlicka, *Edouard Manet* (Zurich, 1941), pp. 82-83 [illustrated]; H. Graber, *Edouard Manet nach eigenen und fremden Zeugnissen* (2nd ed. Basel, 1941), pp. 85, 86, 298, no. 35; M. Florisoone, *Manet* (Monaco, 1947), p. XXIII; A. Tabarant, *Manet et ses oeuvres* (3rd ed. Paris, 1947), pp. 55, 137, 492, 534, 603, no. 57 [illustrated]; N. G. Sandblad, *Manet, Three Studies in Artistic Conception* (Lund, 1954), p. 96; A. L. Chanin, "The Unerring Taste of Stephen Clark," *The Art Digest, 28* (January 1, 1954), p. 13 [illustrated]; E. C. M.,"To Honor the Metropolitan," *Art News, 52* (January, 1954), p. 36 [illustrated]; H. Comstock, "The Connoisseur in America," *Connoisseur, 133* (June, 1954), p. 289 [illustrated]; "The Art Acquired by Yalemen," *Life Magazine* (May 28, 1956), p. 71 [illustrated]; "Accessions of American and Canadian Museums," *Art Quarterly, 24* (1961), p. 400 [illustrated]; P. Courthion, *Edouard Manet* (New York [1961]), p. 68 [illustrated]; "Yale Exhibits Clark Bequest," *Art Journal, 21* (1961-62), p. 118 [illustrated]; "La Chronique des Arts" in *Gazette des Beaux Arts*, 6. période, 59 (1962), p. 40, pl. 147; "Recent Gifts and Purchases," *Bulletin, Y.U.A.G., 28* (December, 1962), p. 12 [illustrated].

When *Jeune femme couchée en costume espagnol* was exhibited at the Galerie Martinet, Boulevard des Italiens, in March 1863 with thirteen other paintings by Manet, including *Lola de Valence, Les Gitanos, La Musique aux Tuileries*, the critics reacted violently. Five of the pictures, among them *Young Woman Reclining, in Spanish Costume*, have been caricatured.[1]

As the dedication on the painting itself points out, Manet presented it to his friend Félix Tournachon, called Nadar. It is usually assumed that Victorine Meurend, who posed for the *Déjeuner sur l'herbe*, the *Olympia*, and various other paintings, was also the model for *Jeune femme couchée en costume espagnol*. But according to A. Tabarant, a friend of Nadar posed as the young woman in Spanish costume.[2] The *Young Woman Reclining, in Spanish Costume* was painted during Manet's so-called "early Spanish period." It has very often been considered a pendant to the *Olympia*, thus echoing Goya's *Maja vestida* and *Maja desnuda*.[3] But the woman reclining on a sofa has a long history

in French painting and was a motif much favored in the latter part of the nineteenth century; Manet himself used it for several portraits. The Yale painting might be seen in the light of this tradition rather than as a pendant to the *Olympia*.

The Yale University Art Gallery possesses a watercolor study for the painting. (Gift of John S. Thacher, B.A. 1927, Acc. No. 1959.63). The watercolor shows the same arrangement and color scheme as the painting with the exceptions that the composition is cutting the bottom part of the sofa and that the woman's right arm lies in a somewhat awkward position high up on a pile of cushions.

1. Reproduced in Moreau-Nélaton, *Manet* (1926), *1*, fig. 46.
2. Tabarant, *Manet* (1947), p. 55.
3. Jamot was the first to connect these two paintings and relate them to Goya. Cf. Jamot, *Burlington Magazine* (1927), p. 32.

Henri Matisse
Cateau-Cambrésis 1869 – Cimiez 1954

NATURE MORTE: À LA STATUETTE, 1906 (PLATE 25).

Bequest of Mrs. Kate Lancaster Brewster. Acc. No. 1948.121.

Oil on canvas; 540 x 451 mm. (21¼ x 17¾ in.).

Inscriptions: Signed at bottom left: *Henri-Matisse*.

Provenance: Oskar and Greta Moll, Breslau and Munich; Moderne Galerie Thannhauser, Berlin; Kate Lancaster Brewster, Chicago (acquired from Thannhauser, 1929).

Exhibitions: Paris, Grand Palais, *Salon d'Automne*, 1906, no. 1173.

Bibliography: "Accessions 1947-48," *Bulletin*, Y.U.A.G., *16* (July, 1948), p. 3, no. 3 [as *Still Life with Torso*]; A. H. Barr, *Matisse, His Art and His Public* (New York, 1951), pp. 83, 93, 105, 329, 558 [illustrated]; G. Diehl, *Henri Matisse* (Paris, 1954), pp. 34, 47; G. Diehl, *Henri Matisse* (Paris and New York, 1958), p. 37; J. Leymarie, *Fauvism* (Lausanne, 1959), p. 94; E. C. Carlson, "*Still Life with Statuette* by Henri-Matisse," *Bulletin* Y.U.A.G., *31* (Spring, 1967), pp. 4-31 [illustrated].

Nature morte: à la statuette was part of the collection of Oskar and Greta Moll, young painters, who were students at the Académie Matisse in 1908. The Molls possessed several paintings and sculptures by Matisse, which they probably acquired in 1907 and 1908.

After the Fauve movement gained much public attention at the famous *Salon d'Automne* of 1905, Matisse exhibited at the *Salon des Indépendants* in the spring of 1906 and had at the same time a large one-man show at the Galerie Druet. Shortly after these two exhibitions opened, Matisse made his first trip to North Africa and afterward spent the summer in Collioure, where he had already stayed in 1905. Matisse's summer of 1906 was extremely fruitful. He completed a series of landscapes, some portraits, and a group of still lifes, among them the Yale picture, which is painted in bright coherent color areas and appears as a fluidly decorated surface. It is probably a study of what Cézanne had called "*modulation*," the tonal values on a surface of colors in light and space. The white female plaster figure on the table is the model for Matisse's bronze *Nu debout* of 1906;[1] it also appears in the *Still Life with Melon* (Merion, Pa., Barnes Foundation).[2] One of Matisse's paintings, *Fleurs, peint à Cavalière*, is represented in the background behind the table.[3]

1. Reproduced in Barr, *Matisse* (1951), p. 327.
2. Reproduced in A. Barnes, *The Art of Henri Matisse* (New York, 1933), p. 236.
3. Reproduced in *Cahiers d'Art*, nos. 5-6 (1931), p. 266, fig. 35, where it is incorrectly dated 1909. This information was obtained from Matisse's daughter, Madame Marguerite G. Duthuit, in a letter to Mr. E. Carlson.

Jean Metzinger
Nantes 1883 — Paris 1956

LE PORT, 1920 (PLATE 36).
(The Port)

Collection of the Société Anonyme. Acc. No. 1941.565.

Oil on canvas; 804 x 540 mm. (31⅞ x 21¼ in.).

Inscriptions: Signed at bottom left: *Metzinger;* signed on the reverse in black chalk: *Metzinger.*

Provenance: Léonce Rosenberg, Paris; Collection of the Société Anonyme, New York (bought from Léonce Rosenberg in 1926).

Exhibitions: New York, Brooklyn Museum, *An International Exhibition of Modern Art Assembled by the Société Anonyme,* 1926-27, no. 44; New York, Anderson Galleries, *International Exhibition of Modern Art Assembled by the Société Anonyme,* 1927, no. 25; Springfield, Mass., The George Walter Vincent Smith Art Gallery, *Some New Forms of Beauty, 1909-1936, A Selection of the Collection of the Société Anonyme,* 1939, no. 39; New Haven, Y.U.A.G., *Exhibition Inaugurating the Collection of the Société Anonyme,* 1942, no. 59; Travelling Exhibitions 1945-46; 1946-47; Minneapolis, Minn., The Walker Art Center, *The Classic Tradition in Contemporary Art,* 1953, no. 81.

Bibliography: W. George, "Jean Metzinger," *Bulletin de l'Esprit Nouveau,* 2 (February, 1922), pp. 1781 ff. [illustrated]; G. H. Hamilton, "The Exhibition of the Collection of the Société Anonyme-Museum of Modern Art: 1920," *Bulletin,* Y.U.A.G., *10* (December, 1941), p. 3; K. S. Dreier and M. Duchamp, *Collection of the Société Anonyme: Museum of Modern Art 1920* (New Haven, 1950), pp. 99-100 [illustrated].

An old label on the reverse referring to the Léonce Rosenberg Gallery dates the painting 1920.

Jean François Millet

Gruchy (near Cherbourg) 1814 – Barbizon 1875

NUIT ETOILÉE, C. 1850-51 (PLATE 6).
(Starry Night)

Leonard C. Hanna, Jr., B.A. 1913, Fund. Acc. No. 1961.22.

Oil on canvas; 654 x 816 mm. (25¾ x 32⅛ in.).

Inscriptions: Signed at the bottom right: *J. F. Millet;* red wax seal on the reverse: *Vente, J. F. Millet;* handwritten label on the reverse: *This picture "Nuit étoilée" was sold at the sale* | *of Millet's pictures on 11th, May 1875* | *I bought it from Goupil on the 26th. of Feb: 1878* | *It was lined with a strong canvas. Placed on* | *a panelled strainer at the suggestion of Holman* | *Hunt – by*

Mr. [?] *Eatwell – on the 15th of February 1878* | *Mr. Eatwell took the seal from the old frame &* | *stuck it on this one –* | *Geo. Lillie Craik.*

Provenance: Atelier Millet (sale, Paris, Hôtel Drouot, May 10-11, 1875, no. 32 [dated 1867]); Galerie Goupil, London; George Lillie Craik, London (since 1878); J. S. Knapp-Fisher, London (by descent).

Exhibitions: London, Hazlitt Gallery, *Some Paintings of the Barbizon School, No. 4,* 1958, no. 32; San Francisco, Palace of the Legion of Honor; Toledo, Museum of Art; Cleveland, Museum of Art; Boston, Museum of Fine Arts, *Barbizon Revisited,* 1962, no. 64 [illustrated].

Bibliography: T. Mullaly, "Barbizon School Paintings," *Daily Telegraph and Morning Post* (London, May 12, 1958), p. 10; "Hazlitt Gallery," *The Times* (London, May 12, 1958), p. 14; "Recent Gifts and Purchases," *Bulletin,* Y.U.A.G., *28* (December, 1962), p. 49.

According to R. L. Herbert, the date given in the Millet studio sale catalogue,[1] 1867, is too late. He dates *Starry Night* about 1850-51 for stylistic reasons, but he believes that the painting was probably retouched in the area around the trees about 1866-68.[2] This painting has been related to Vincent van Gogh's *Nuit étoilée* (1888), which might well echo it. The young Vincent could very well have seen *Starry Night* while working in Goupil's firm in London and Paris from 1873-76. Van Gogh admired Millet very much and liked to copy his drawings. In the letters to Theo he writes again and again how deeply he was impressed by Millet's art.

1. R. L. Herbert, *Barbizon Revisited,* Exhibition Catalogue (Boston, 1962), p. 150.
2. Paris, Hôtel Drouot, Millet Sale, 1875, no. 32.

Amadeo Modigliani

Livorno (Italy) 1884 – Paris 1920

PORTRAIT OF A YOUNG WOMAN, C. 1918
(PLATE 34).

Bequest of Mrs. Kate Lancaster Brewster. Acc. No. 1948.123.

Oil on canvas; 458 x 280 mm. (18 x 11 in.).

Inscriptions: Signed at top right: *modigliani*

Provenance: Leopold Zborowski, Paris; Mrs. Cornelius J. Sullivan, New York; Kate Lancaster Brewster, Chicago (since 1935).

Exhibitions: Boston, Museum of Fine Arts, and Los Angeles, County Museum, *Paintings and Drawings, Modigliani*, 1961, no. 31 [illustrated].

Bibliography: "Accessions 1947-48," *Bulletin*, Y.U.A.G., *16* (July, 1948), p. 3.

The identification of the Yale portrait as "Jeanne Hébuterne" is incorrect.[1] If this portrait is compared with others of Modigliani's companion, no similarities whatsoever can be found. However, the portrait can easily be grouped with several others (some of them also incorrectly identified), all of which depict the same young woman, a model or friend of the artist.[2]

Modigliani sometimes painted several versions of the same portrait; only the first portrait done with the sitter and the others painted later as variations. This could be true of these four portraits (listed in note 2), all of which were probably painted during the period, 1918-19.[3]

1. Cf. letter of Mrs. Cornelius J. Sullivan, 1935, Y.U.A.G. files, who acquired the painting under this title from the Zborowski Collection.
2. Cf. J. Modigliani, *Modigliani, Man and Myth* (New York, 1958), fig. 47. Probably identical with no. 299 of A. Pfannstiel, *Modigliani et son oeuvre* (Paris, 1956); A. Ceroni, *Amadeo Modigliani, peintre* (Milan, 1958), no. 85; *Paintings and Drawings, Modigliani* (Los Angeles, County Museum, 1961), no. 30 [illustrated].
3. One of the four portraits (reproduced in J. Modigliani, fig. 47) is dated 1918.

Adolphe Joseph Thomas Monticelli
Marseilles 1824 – 1886

THE BARNYARD, C. 1865 (PLATE 9).

Gift of Duncan Phillips, B.A. 1908. Acc. No. 1939.266.

Oil on wood panel; 400 x 584 mm. (15¾ x 23 in.).

Inscriptions: Signed at bottom left: *Monticelli*.

Provenance: Kraushaar Gallery, New York; Duncan Phillips, Washington, D.C. (since 1921).

The painting was formerly attributed to Monticelli and Matthijs Maris.

GARDEN SCENE, C. 1875-78 (PLATE 9).

Bequest of Blanche Barclay for the George C. Barclay Collection. Acc. No. 1949.233.

Oil on wood panel; 391 x 616 mm. (15⅜ x 24¼ in.).

Inscriptions: Signed at bottom right: *Monticelli*.

Provenance: George C. Barclay, New York; Blanche Barclay, New York.

Bibliography: "Accessions 1949-1950," *Bulletin*, Y.U.A.G., *19* (January, 1951).

A very similar version of *Garden Scene* was exhibited in Springfield, Mass., The George Walter Vincent Smith Art Gallery, *Paintings by A. J. T. Monticelli*, 1941, no. 11 [illustrated]. It was then in the collection of Mrs. Robert C. Vose.

Jean Baptiste François Pater
Valenciennes 1695 – Paris 1736

SCÈNE GALANTE DANS UN PARC, C. 1725-35 (PLATE 3).

Gift of Mrs. André Blumenthal, in memory of her mother, Annie C. Wimpfheimer. Acc. No. 1957.28.

Oil on canvas; 527 x 689 mm. (20¾ x 27⅛ in.).

Inscriptions: Stamped with red wax seal on the stretcher: BACHSTITZ / *Collection* / *La Haye*.

Provenance: Hermann Frenkel, Berlin; Engelhorn (according

to Wildenstein bill); Jacques Seligmann, Paris (according to Frick Art Reference Library files); Bachstitz Gallery, The Hague (Bachstitz Catalogue, 1921); Wildenstein, Paris; Charles A. Wimpfheimer, New York (bought from Wildenstein in 1925); André and Mildred Blumenthal, Norwalk, Conn.

Exhibitions: Berlin, Koenigliche Akademie der Kuenste, *Ausstellung von Werken franzoesischer Kunst des XVIII. Jahrhunderts*, 1910, no. 137 (no. 103 of illustrated catalogue); New Haven, Y.U.A.G., *Pictures Collected by Yale Alumni*, 1956, no. 16 [illustrated].

Bibliography: *Catalogue of Paintings and Tapestries, The Bachstitz Gallery 1* (Berlin [1921 ?]), no. 66 [illustrated; as *Fête champêtre* by Antoine Watteau]; F. Ingersoll-Smouse, *Pater, biographie et catalogue critique* (Paris, 1928), p. 56, no. 243, pl. 64; "New Acquisitions Issue," *Bulletin*, Y.U.A.G., *24* (April, 1958), p. 9 [illustrated].

A variant is *La Danse* in the Wallace Collection in London,[1] but like most of Pater's paintings it is not dated. The Yale painting, however, is stylistically close to two dated pictures, *La Fête de la foire de Bezons* (1733) and *Concert champêtre* (1734).[2] *Scène galante dans un parc* was probably executed during the last decade of Pater's life.

1. F. Ingersoll-Smouse, *Pater* (1928), no. 231, fig. 52.
2. Ibid., nos. 54, 19.

Francis Picabia
Paris 1879 – 1953

MIDI, C. 1920-29 (PLATE 37).

Collection of the Société Anonyme. Acc. No. 1941.634.

Oil, feathers, macaroni and leather on canvas with snakeskin frame by Pierre Legain; 553 x 997 mm. (21¾ x 39¼ in.).

Provenance: Collection of the Société Anonyme, New York (gift of the artist in 1937).

Exhibitions: Springfield, Mass., The George Walter Vincent Smith Art Gallery, *Some New Forms of Beauty, 1909-1936, A Selection of the Collection of the Société Anonyme*, 1939, no. 52.

Bibliography: K. S. Dreier and M. Duchamp, *Collection of the Société Anonyme*: *Museum of Modern Art 1920* (New Haven, 1950), pp. 4-5 [illustrated].

Pablo Picasso
Malaga (Spain) 1881 –

CHIEN ET COQ, 1921 (PLATE 41).
(Dog and Cock)

Gift of Stephen C. Clark, B.A. 1903. Acc. No. 1958.1.

Oil on canvas; 1549 x 765 mm. (61 x 30⅛ in.).

Inscriptions: Signed and dated at top left: *Picasso / 21*.

Provenance: Galerie Paul Rosenberg, Paris (bought from the artist in 1921; according to P. Rosenberg, letter, New York, May 5, 1964); Jérome Stoneborough, Paris; Galerie Paul Rosenberg, Paris (bought in 1939); Museum of Modern Art, New York (bought in 1942); Stephen C. Clark, New York (bought in 1949).

Exhibitions: Chicago, The Art Institute, *20th Century French Painting from the Collection of Paul Rosenberg*, 1941; New York, Museum of Modern Art, *Cubist and Abstract Art*, 1942; Mexico City, *La Exposición de la Sociedad Arte Moderno, Picasso*, 1944, pp. 42, 57 [illustrated]; Toronto, The Art Gallery of Toronto, *Picasso*, 1949, no. 13; New York, Paul Rosenberg & Co., *Loan Exhibition of Paintings by Picasso*, 1955, no. 2 [illustrated]; Boston, Museum of Fine Arts, *European Masters of Our Time*, 1957, no. 116, pl. 66; New York, Paul Rosenberg & Co., *Picasso, an American Tribute, the Twenties*, 1962, no. 25 [illustrated].

Bibliography: A. H. Barr, Jr., ed., *Painting and Sculpture in the Museum of Modern Art* (New York, 1942), p. 67, no. 486 [illustrated]; "Abstracts at Modern," *Art Digest, 16* (April 15, 1942), p. 10 [illustrated]; A. H. Barr, Jr., *Picasso, Fifty Years of His Art* (New York, 1946), p. 120 [illustrated]; J. Merli, *Picasso, el artista y la obra de nuestro tiempo* (2nd ed. Buenos Aires, 1948), pl. 252; *Art News Annual, 20*, Pt. 2 (1950), p. 134 [illustrated]; C. Zervos, *Pablo Picasso* (Paris, 1951), 4, no. 335, pl. 129; A. Vallentin, *Pablo Picasso* (Paris, 1957), p. 249; *College Art Journal, 17*, no. 3 (1958) [illustrated on the cover];

"Accessions of American and Canadian Museums," *Art Quarterly*, *21* (1958), p. 227; "New Acquisitions Issue," *Bulletin*, Y.U.A.G., *24* (April, 1958), p. 17 [illustrated]; R. Rosenblum, *Cubism and 20th Century Art* (New York, 1960), p. 102, pl. xv.

After the birth of his son Paulo, Picasso rented a villa in Fontainebleau, where he spent the summer of 1921. Here he painted the two famous versions of the *Three Musicians* (New York, Museum of Modern Art and Philadelphia Museum of Art). Very close to them in style and in color scheme is *Dog and Cock*, painted in the same year.

CORBEILLE DE FLEURS ET PICHET, 1937
(PLATE 40).
(Vase of Flowers and Pitcher)

Gift of Stephen C. Clark, B.A. 1903. Acc. No. 1954.29.1.

Oil on canvas; 596 x 699 mm. (23 7/16 x 27½ in.).

Inscriptions: Signed and dated at bottom right: *Picasso mars 37.*

Provenance: Galerie Paul Rosenberg, Paris (bought from the artist); Stephen C. Clark, New York (bought from Rosenberg in 1948). (Provenance according to Rosenberg, letter, New York, April 25, 1964).

Exhibitions: New York, Paul Rosenberg & Co., *Paintings by Picasso*, 1947, no. 12; New York, Paul Rosenberg & Co., *Picasso, Drawings, Gouaches, Paintings from 1913 to 1947*, 1948, no. 23.

Bibliography: J. Merli, *Picasso, el artista y la obra de nuestro tiempo* (2nd ed. Buenos Aires, 1948), pl. 445; B. Wolf, "Pablo Picasso Between Two Wars," *Art Digest, 21* (February 15, 1947), p. 11 [illustrated]; M. Breuning, "Picasso Pictures that Explain His Fame," *Art Digest, 22* (April 1, 1948), p. 16 [illustrated]; "Accessions 1954," *Bulletin*, Y.U.A.G., *21* (March, 1955), p. 12; C. Zervos, *Pablo Picasso* (Paris, 1957), *8*, p. 168, no. 356 [illustrated; as *Nature morte*].

Vollard had found an old farmhouse in LeTremblay-sur-Mauldre, not far from Versailles, which Picasso had taken in late fall 1936 as a welcome possibility to work in seclusion. Even when he began to work on *Guernica* in his Paris studio in May 1937, he used to spend a few days each week in his country retreat, where he painted the portraits of Marie-Thérèse and Maïa, their daughter, and continued a series of still lifes, which he had begun late in 1936. *Basket of Flowers and Pitcher* is one of them; it is typical in the objects depicted. Most of these small still-life compositions have familiar objects such as fruit, flowers, pitchers, jugs, fish, or candles, and their simple homey atmosphere and quiet charm show nothing of the tragic mood of *Guernica*.

LES PREMIERS PAS, 1943 (PLATE 42).
(The First Steps)

Gift of Stephen C. Clark, B.A. 1903. Acc. No. 1958.27.

Oil on canvas; 1302 x 971 mm. (51¼ x 38¼ in.).

Inscriptions: Signed at top right: *Picasso;* dated on reverse in black chalk: *21 mai 43.*

Provenance: Samuel M. Kootz Gallery, New York (bought from the artist in 1947); Stephen C. Clark, New York (bought in 1948). (Provenance according to Kootz, letter, New York, April 23, 1964).

Preparatory studies: Cf. C. Zervos, *Pablo Picasso* (Paris, 1962), *13*, nos. 15-18, 20, 34-35, 40 [all illustrated].

Exhibitions: Paris, *Salon d'Automne, Exposition Picasso*, 1944, no. 3; Avignon, Palais des Papes, *Exposition de peintures et sculptures contemporaines*, 1947, no. 147; New York, Samuel M. Kootz Gallery, *Picasso, The First World Showing of Paintings of 1947*, 1948, no. 12; São Paulo, Museu de arte moderno, *2 Bienal* (Sala especial Pablo Picasso), 1953-54, no. 44; New York, Museum of Modern Art, *Paintings from Private Collections*, 1955, (p. 17 of catalogue); New York, Museum of Modern Art and Chicago, Art Institute, *Picasso: 75th Anniversary Exhibition*, 1957 [illustrated]; Philadelphia, Museum of Art, *Picasso, a Loan Exhibition of His Paintings, Drawings, Sculpture, Ceramics, Prints and Illustrated Books*, 1958, no. 210 [illustrated]; London, Tate Gallery, The Arts Council of Great Britain, *Picasso*, 1960, no. 170, pl. 39a; Worcester, Mass., Worcester Art Museum, *Picasso, His Later Works, 1938-61*, 1962, no. 14 [illustrated].

Bibliography: *Cahiers d'Art, 15-19* (1940-44) [illustrated: following p. 42]; H. and S. Janis, *Picasso, The Recent Years 1939-46* (New York, 1946), pls. 3, 105; A. H. Barr, Jr., *Picasso, Fifty Years of His Art* (New York, 1946), pp. 232-33, 246 [illustrated]; J. Merli, *Picasso, el artista y la obra de nuestro tiempo* (2nd ed. Buenos Aires, 1948), pl. XXXVI; J. Sabartés, *Picasso, documents iconographiques* (Geneva, 1954), pl. 144; A. Vallentin, *Pablo Picasso* (Paris, 1957), p. 353; "Accessions of American and Canadian Museums," *Art Quarterly, 21* (1958), p. 229 [illustrated]; R. Penrose, *Picasso: His Life and Work* (2nd ed. New York, 1962), p. 307, pl. XXI, 1; "Exhibitions," *College Art Journal, 18* (1959), p. 355 [illustrated]; "Recent Gifts and Purchases," *Bulletin, Y.U.A.G., 24-25* (April, 1959), p. 36 [illustrated]; C. Zervos, *Pablo Picasso* (Paris, 1962), *13*, no. 36, pl. 17.

Picasso spent most of the war years in Paris, to which he had returned from Royan in October 1940. Many of his works dating from the years of the war were shown for the first time at the *Salon de la Libération* (*Salon d'Automne* 1944), where *First Steps* was hung in a prominent place.

Picasso has long been preoccupied with the subject of mother and child. He painted this theme in his early period from about 1901-06, then in the early twenties after the birth of his first son, and much later after the Second World War, when his two youngest children were born. But *First Steps* is unique among the many paintings of mother and child in the specific crucial moment it depicts.

We know from films and stills, taken during the process of painting, that Picasso frequently evolves and alters his work thoroughly through a long cycle of changes. The many preparatory studies for *First Steps* indicate that the painting went through a rather long evolution from its first idea to the final state. In Zervos, nos. 16-18 are pencil drawings, showing the mother bending over her child who lies in her arms, barely suspended above the ground. Nos. 20 and 40 are very close to the painting, but with the fundamental difference that the child is smaller. No. 20 as well as no. 34 (head of the child) is dated later than the

painting: no. 20 is dated August 31, 1943; no. 34, August 17, 1943. Both, however, are apparently preparatory studies, particularly no. 34; they are different steps of the final composition. Only in the painting does the child grow to enormous size. Because these two drawings are dated later than the canvas, it is obvious that the painting was finished later than May 1943, probably after August 1943.

Pierre Puvis de Chavannes
Lyon 1824 – Paris 1898

DOUX PAYS, 1882 (PLATE 15).
(Pleasant Land)

Mary Gertrude Abbey Fund. Acc. No. 1958.64.

Oil on canvas; 258 x 473 mm. (10⅛ x 18⅝ in.).

Inscriptions: Signed at the bottom left: *P. Puvis de Chavannes.*

Provenance: Albert Wolff, Paris (according to exhibition catalogue, Paris, Durand-Ruel, 1887, no. 83); Henri Vever, Paris; Dr. W. Feilchenfeldt, Zurich.

Preparatory studies: A drawing of the two fighting boys was exhibited at the Musée de la Ville de Lyon: *Puvis de Chavannes et la peinture lyonnaise du XIXe siècle* (1937), no. 26. Three other drawings were exhibited in Paris, Musée Galliéra: *Dessins et petits tableaux de P. Puvis de Chavannes* (1952), nos. 9, 41, 62.

Exhibitions: Paris, *Salon,* 1882, no. 2224; Paris, Durand-Ruel, *Exposition de tableaux, pastels, dessins par M. Puvis de Chavannes,* 1887, no. 83; Paris, Galerie Paul Rosenberg, *Exposition d'oeuvres de grands maîtres du XIXe siècle,* 1922, no. 70; Paris, Musée des Arts Décoratifs, *Cinquante ans de peinture française,* 1925, no. 60; Amsterdam, Rijksmuseum, *Exposition rétrospective d'art français,* 1926, no. 92; Paris, Galerie Paul Rosenberg, *Exposition d'oeuvres importantes de grands maîtres du XIXe siècle,* 1931, no. 63; London, Royal Academy of Arts, *French Art, 1200-1900,* 1932, no. 480 (no. 475 of the Commemorative Catalogue, 1933); Paris, Palais National des Arts, *Chefs d'oeuvre de l'art français,* 1937, no. 387; Essen, Villa Huegel, *Werke der franzoesischen Malerei und Grafik des 19. Jahrhunderts,* 1954, no. 80.

Bibliography: H. Durand-Tahier, "Puvis de Chavannes," *La Plume*, no. 138 (1895), p. 30 [illustrated], (mural at the Musée Bonnat); Rood [Lily Lewis], *Puvis de Chavannes* (Boston, 1895), p. 5; M. Vachon, *Puvis de Chavannes* (Paris, 1895), pp. 123-24 [illustrated opposite p. 48] (mural at the Musée Bonnat); L. Riotor, *Essai sur Puvis de Chavannes* (Paris, 1896), pp. 36, 42; W. H. Low, "Century of Painting," *McClure's Magazine*, 8 (April, 1897), p. 475 [illustrated] (mural at the Musée Bonnat); A. Alexandre, "Puvis de Chavannes," *Figaro Illustré*, no. 107 (Paris, February, 1899), p. 44 [illustrated on the cover] (mural at the Musée Bonnat); A. Alexandre, *Puvis de Chavannes* (London, and New York, 1905), pl 52; C. Rickets, "Puvis de Chavannes: A Chapter from 'Modern Painters,'" *Burlington Magazine*, 13 (1908), pp. 12-17; A. Michel and J. Laran, *Puvis de Chavannes* (Philadelphia, 1912), pp. 59 ff, pl. XXXI; R. Jean, *Puvis de Chavannes* (Paris, 1914), pp. 92 ff., pl. XV (mural at the Musée Bonnat); L. Bénédite, *Notre art, nos maîtres* (Paris, 1922), pp. 48, 62; G. Janneau, "Les grandes expositions. Maîtres du siècle passé," *La Renaissance de l'Art Français*, 5 (1922), p. 340 [illustrated] (summary of the exhibition at Rosenberg); L. Werth, *Puvis de Chavannes* (Paris [1926]), p. 34n; C. Mauclair, *Puvis de Chavannes* (Paris, 1928), pp. 14, 15, 121, pl. XXIX (mural at the Musée Bonnat); A. Declairieux, *Puvis de Chavannes et ses oeuvres* (Lyon, 1928), pp. 108 ff. [illustrated] (mural at the Musée Bonnat); P. Jamot, "French Painting II," *Burlington Magazine*, 60 (1932), p. 3, pl. XLVIII (mural at the Musée Bonnat); J. E. Blanche, "Le XIXᵉ siècle," *Gazette des Beaux-Arts*, 6. période, 7 (1932), p. 77 [illustrated]; R. Goldwater, "Puvis de Chavannes: Some Reasons for a Reputation," *Art Bulletin*, 28 (1946), p. 36; J. Seznec, "Literary Inspiration in van Gogh," *Magazine of Art*, 43 (1950), pp. 306-07 [illustrated] (mural at the Musée Bonnat); "Notable Works of Art Now on the Market," *Burlington Magazine*, 95 (Supplement, December, 1953), pl. XXVII; M. Schapiro, "New Light on Seurat," *Art News*, 57 (April, 1958), p. 44 [illustrated]; W. I. Homer, "Seurat's Formative Period: 1880-1884," *Connoisseur*, 142 (1958), p. 62, fig. 14 (mural at the Musée Bonnat); "Recent Gifts and Purchases," *Bulletin*, Y.U.A.G., 24-25 (April, 1959), pp. 26, 49 [illustrated]; R. L. Herbert, "Seurat and Puvis de Chavannes," *Bulletin*, Y.U.A.G., 25 (October, 1959), pp. 22-29 [illustrated].

Puvis de Chavannes painted *Doux Pays* for his friend, the painter Léon Bonnat. The Yale picture is a finished study for the mural (now in the Musée Bonnat, Bayonne) executed for the stairway hall of Bonnat's house in Paris.

Doux Pays was Puvis' only private commission for a mural decoration. The small model is very carefully executed in every detail and differs very little from the Bonnat mural. The painting, with its simplification of form and its idyllic gentle mood, marks the beginning of Puvis' late style.

Vincent van Gogh, who admired Puvis' paintings very much, wrote from Arles in the fall of 1888 to his brother Theo: "when you have seen the cypresses and the oleanders here . . . then you will think even more often of the beautiful *Pleasant Land* by Puvis de Chavannes, and many other pictures of his."[1]

1. *The Complete Letters of Vincent van Gogh* (3 vols., Greenwich, Conn., 1958), *3*, p. 43, no. 539.

Odilon Redon
Bordeaux 1840 – Paris 1916

APOLLO, C. 1905-10 (PLATE 24).

The Philip L. Goodwin Collection, B.A. 1907. Acc. No. 1958.20.

Oil on canvas; 731 x 543 mm. (28¾ x 21⅜ in.).

Inscriptions: Signed at bottom left: *Odilon Redon*.

Provenance: John Quinn, New York; Brummer Gallery, New York (bought by Joseph Brummer from the Quinn Collection at Art Center Show about 1924); Philip L. Goodwin, New York (bought 1926).

Exhibitions: Hartford, Conn., Wadsworth Atheneum (according to catalogue, Cleveland, Museum of Art, *Twentieth Anniversary Exhibition*, 1936); New York, Metropolitan Museum, *Loan Exhibition of Impressionist and Post-Impressionist Paintings*, 1921, no. 91 [illustrated]; Cleveland, Museum of Art, *Twentieth Anniversary Exhibition*, 1936, no. 340; New Haven, Y.U.A.G., *French Paintings of the Latter Half of the Nineteenth Century from the Collections of Alumni and Friends of Yale*, 1950, no. 14 [illustrated]; New

York, Paul Rosenberg, *Paintings and Pastels by Odilon Redon*, 1959, no. 15 [illustrated].

Bibliography: M. W. Watson, "Odilon Redon, A Great French Lyricist," *The Arts*, 2 (1922), p. 274 [illustrated]; *The John Quinn Collection of Paintings, Water Colors, Drawings and Sculpture* (New York, 1926), pp. 14, 105 [illustrated]; R. Bacou, *Odilon Redon* (2 vols. Geneva, 1956), 1, p. 161n; "Recent Gifts and Purchases," *Bulletin*, Y.U.A.G., *24-25* (April, 1959), pp. 27, 50 [illustrated].

Redon did many variations in oil or pastel of Phaeton and Apollo with the chariot; most were done during the period of 1900-10.[1] The only dated version seems to be *Le Jour*, which is part of the decoration of the library at the Abbey of Fontfroide and was commissioned by Redon's friends, the Fayet family. These panels were finished in the fall of 1911.

Apollo's chariot appeared for the first time in Redon's lithographed series *Temptation de St. Antoine* (1888), when the artist himself was still dedicated to the "Noirs."[2] From 1905 on the Apollo theme reappeared more often in Redon's work. It had a strong symbolic meaning for the painter, who had been deeply impressed by Moreau's *Phaeton* and particularly by Delacroix's Apollo chariot on the ceiling in the Louvre. As early as 1878 he wrote: "Here is the work which he made in the fullness of his talent and of his power. What is the great expression in it, the principal feature? It is the triumph of light over darkness. It is the joy of the full daylight opposed to the sadness of the night and of the shadows, and it is like the joy of a better feeling after anguish."[3]

1. Cf. Ari Redon, ed., *Lettres à Odilon Redon*, texts and notes by Roseline Bacou (Paris, 1960), p. 24.
2. Cf. Odilon Redon, *Oeuvre graphique complet* (La Haye, 1913), no. 57.
3. O. Redon, *A Soi-Même, Journal 1867-1915* (Paris, 1961), p. 175.

Pierre Auguste Renoir
Limoges 1841 – Cagnes 1919

SEATED GIRL IN LANDSCAPE, C. 1900 (PLATE 21).

Gift of Henry R. Luce, B.A. 1920. Donor's wife retaining life interest. Acc. No. 1962.52.

Oil on canvas; 381 x 280 mm. (15 x 11 in.).

Inscriptions: Signed at the top left: *Renoir*.

Provenance: Ambroise Vollard, Paris; Paul Rosenberg, New York (bought from the heirs of Vollard about 1954-55); Henry R. Luce, New York (bought from Rosenberg in 1955). Provenance according to Alexandre Rosenberg, letter, January 4, 1965.

Bibliography: A. Vollard, *Tableaux, pastels & dessins de Pierre Auguste Renoir* (2 vols. Paris, 1918), *1*, p. 21, no. 83 [illustrated]; "Recent Gifts and Purchases," *Bulletin*, Y.U.A.G., *29* (April, 1963), p. 27 [illustrated].

The illustration in Vollard's book was reproduced from a photograph countersigned in the margin by the artist: "*La Boulangère*," which refers to the model, Marie Dupuis, whom Renoir met in 1899.[1]

1. J. Renoir, *Renoir My Father* (Boston and Toronto, 1958), pp. 370-72 ff.

Georges Ribemont-Dessaignes
Montpellier 1884 –

JEUNE FEMME, C. 1918 (PLATE 35).

Collection of the Société Anonyme. Acc. No. 1941.665.

Oil on canvas; 731 x 601 mm. (28¾ x 23⅝ in.).

Inscriptions: Signed at bottom left of center: *Jeune femme* GRD.

Provenance: Collection of the Société Anonyme, New York (bought from the artist in 1920).

Exhibitions: New York, Museum of Modern Art, *Fantastic Art, Dada, Surrealism*, 1936, no. 482; Springfield, Mass., The George Walter Vincent Smith Art Gallery, *Some New Forms of Beauty, 1909-1936, A Selection of the Collection of the Société Anonyme*, 1939, no. 56; New Haven, Y.U.A.G., *Exhibition Inaugurating the Collection of the Société Anonyme*, 1942, no. 73; Travelling Exhibitions 1945-46; 1946-47; Springfield, Mass., Museum of Fine Arts, *In Freedom's Search*, 1950, no. 23;

Houston, Texas, Contemporary Arts Museum, *The Trojan Horse*, *The Art of the Machine*, 1958.

Bibliography: K. S. Dreier and M. Duchamp, *Collection of the Société Anonyme*: *Museum of Modern Art 1920* (New Haven, 1950), p. 187 [illustrated].

Hubert Robert
Paris 1733 – 1808

LE PONT ANCIEN, C. 1760-65 (PLATE 4).
(The Old Bridge)

Gift of Mr. and Mrs. James W. Fosburgh, B.A. 1933. Acc. No. 1957.34.1.

Oil on canvas; 762 x 1003 mm. (30 x 39½ in.).

Provenance: Probably Moreau-Chaslon, Paris (sale Paris, Hôtel Drouot, February 6, 1882, p. 38, no. 106 [as *Pont monumental avec grand escalier et nombreux personnages*]); Camille Groult, Paris; Newhouse Galleries, New York (bought from the Grouet family in 1954).

Preparatory studies: A red chalk counterproof in Besançon, published by M. Feuillet, *Les Dessins d'Honoré Fragonard et de Hubert Robert des bibliothèque et musée de Besançon de la collection P. A. Paris* (Paris, 1926), pl. LXXIX, *Escalier monumental sous un pont orné de statues*, is signed and dated *Roberti 1760*.

Exhibitions: Los Angeles, University of California Art Galleries, *French Masters*: *Rococo to Romanticism*, 1961, p. 26 [illustrated].

Bibliography: P. de Nolhac, *Hubert Robert* (Paris, 1910), p. 142; *Art Quarterly*, *18* (1955), p. 104 [illustrated]; *Art News*, *55* (January, 1957), p. 57 [illustrated]; "New Acquisitions Issue," *Bulletin*, Y.U.A.G., *24* (April, 1958), p. 11 [illustrated]; H. Comstock, "The Connoisseur in America, Acquisitions at the Yale Art Gallery," *Connoisseur*, *143* (1959), p. 273 [illustrated].

During his stay in Rome (1754-65), Hubert Robert certainly studied Giovanni Paolo Pannini's paintings and possibly took lessons from the famous Italian painter of *vedute*; he must have also studied Piranesi, whose *Carceri d'Invenzione* are echoed by *Le Pont ancien*. Because Hubert Robert used his Italian sketches throughout his lifetime for his paintings, the red chalk counterproof in Besançon, dated 1760, does not necessarily date the picture in the same year. Although the dark bridge-stairway construction is much less foreboding than the *Carceri*, the composition built with the same elements is still very close to them. This and the almost Guardi-like sketched figures that appear as colorful spots in the brownish-gray architectural mass suggest a date around 1760-65.[1]

1. Cf. P. de Nolhac, "Les premières années romaines d'Hubert Robert," *La Renaissance de l'Art Français* (January, 1923), pp. 27 ff. Also, E. Hempel, "Fragonard und Robert in ihrer roemischen Studienzeit," *Die graphischen Kuenste*, *47* (1924), Pt. 1, pp. 9 ff. and H. Voss, "Opere giovanili di Hubert Robert in gallerie italiane," *Dedalo*, *8* (1928), pp. 743 ff.

Georges Pierre Seurat
Paris 1859 – 1891

BLACK COW IN A MEADOW, C. 1881 (PLATE 18).

Gift of Walter J. Kohler, B.A. 1925. Donor retaining life interest. Acc. No. 1959.42.

Oil on wood panel (cigar box top); 155 x 241 mm. (6⅛ x 9½ in.).

Provenance: Atelier Seurat, no. 59; Mme. Ernestine F. Seurat (mother), Paris (according to M. J. Puybonnieux, Paris); Jacques and Pierre Puybonnieux, Paris; Wildenstein, New York; Walter J. Kohler, Madison, Wisconsin.

Exhibitions: Paris, Beaux-Arts, *Seurat et ses amis, la suite de l'impressionisme*, 1933-34, Supplement, no. 166.

Bibliography: H. Dorra and J. Rewald, *Seurat, l'oeuvre peint, biographie et catalogue critique* (Paris, 1959), p. 54, no. 57 [illustrated; as *Vache dans un pré*]; "Recent Gifts and Purchases," *Bulletin*, Y.U.A.G., *26* (December, 1960), pp. 25, 54 [illustrated]; C. M. de Hauke, *Seurat et son oeuvre* (2 vols. Paris, 1961), *1*, p. 26, no. 48 [illustrated; as *Dans un Pré*].

According to R. L. Herbert (Y.U.A.G. files), Rewald's date of 1882 and de Hauke's date of 1883 are too late. Herbert dates the painting of 1881 because of the acid yellow-green of the palette.

TWO STONEBREAKERS, C. 1881 (PLATE 18).

Gift of Walter J. Kohler, B.A. 1925. Donor retaining life interest. Acc. No. 1958.91.

Oil on wood panel (cigar box top); 153 x 249 mm. (6 x 9¾ in.).

Inscriptions: Inscribed on reverse in Maximilien Luce's (a Seurat follower) hand: *G. Seurat | L.*

Provenance: Atelier Seurat, no. 13; Paul Levasseur, L'Hôpital par Pacy-sur-Eure; Wildenstein, New York; Walter J. Kohler, Madison, Wisconsin.

Exhibitions: Paris, Musée Jacquemart-André, *Seurat*, 1957 (according to de Hauke, 1961, *1*, p. 20).

Bibliography: H. Dorra and J. Rewald, *Seurat, l'oeuvre peint, biographie et catalogue critique* (Paris, 1959), p. 46, no. 47 [illustrated; as *Casseurs de pierres*]; "Recent Gifts and Purchases," *Bulletin,* Y.U.A.G., *24-25* (April, 1959), pp. 28, 50 [illustrated]; R. L. Herbert, "*Seurat and Puvis de Chavannes,*" *Bulletin,* Y.U.A.G., *25* (October, 1959), pp. 22-29 [illustrated]; C. M. de Hauke, *Seurat et son oeuvre* (2 vols. Paris, 1961), *1*, p. 20, no. 35 [illustrated; as *Deux Paysans aux champs*].

A series of stonebreakers, drawings and oil sketches on small wood panels, were executed at about the same time as the Yale panel (de Hauke, 1961, nos. 30, 33, 36, 38, 100, 102, 555-57). R. L. Herbert identified the subject as *Two Stonebreakers* and dated the painting in the summer of 1881 because of its color scheme.[1]

1. Herbert, *Bulletin,* Y.U.A.G., (October, 1959), p. 23.

Alfred Sisley
Paris 1839 – Moret-sur-Loing 1899

LA SEINE À BOUGIVAL, 1872 (PLATE 13).

Gift of Henry J. Fisher, B.A. 1896. Acc. No. 1962.54.

Oil on canvas; 508 x 655 mm. (20 x 25 in.).

Inscriptions: Signed at bottom left: *Sisley.*

Provenance: Durand-Ruel, Paris (bought from the artist in 1872); Henry J. Fisher, Greenwich, Conn. (bought from Durand-Ruel in 1939).

Exhibitions: London, Grafton Galleries, *Paintings by Boudin, Sisley,* 1905, no. 294, pl. 42; New York, Durand-Ruel, *Paintings by Degas, Renoir, Monet, Pissarro and Sisley,* 1931, no. 1; New York, Durand-Ruel, *Views on the Seine,* 1937, no. 5; New York, Durand-Ruel, *French Paintings from 1870 to 1880,* 1938, no. 7; New York, Durand-Ruel, *Alfred Sisley Centennial,* 1939, no. 9; New Haven, Y.U.A.G., *Paintings, Drawings and Sculpture Collected by Yale Alumni,* 1960, no. 56 [illustrated].

Bibliography: G. Geffroy, *Sisley* (Paris, 1927), pl. 15; R. Frost, "The Seine of the Impressionists," *Art News,* 35 (January, 1937), p. 10 [illustrated]; G. Besson, *Sisley* (Paris, [n.d.]), pl. 25; F. Daulte, *Alfred Sisley, catalogue raisonné de l'oeuvre peint* (Lausanne, 1959), no. 39 [illustrated]; "Recent Gifts and Purchases," *Bulletin,* Y.U.A.G., *29* (April, 1963), p. 26 [illustrated].

Maurice Utrillo
Paris 1883 – Dax (Landes) 1955

RUE DE VILLAGE, C. 1910 (PLATE 26).

Gift of Miss Edith Wetmore. Acc. No. 1945.2.

Oil on canvas; 599 x 807 mm. (23 9/16 x 31¾ in.).

Inscriptions: Signed at bottom left: *Maurice Utrillo V.*

Provenance: Probably Louis Libaude, Paris; Edith Wetmore, New York.

Exhibitions: New York, Marie Harriman Gallery, *Masterpieces by Utrillo,* 1941, no. 7; Pittsburgh, Pa., Carnegie Institute, Museum of Art, *Maurice Utrillo,* 1963, no. 110 [illustrated].

Bibliography: "Recent Accessions," *Bulletin,* Y.U.A.G., *13* (June, 1945), p. 5.

Rue de Village belongs to Utrillo's so-called "white period" and was probably executed about 1910.

Jacques Villon (Gaston Duchamp)
Damville (Eure) 1875 – Puteaux-sur-Seine 1963

LA TABLE SERVIE, 1912-13 (PLATE 30).

Collection of the Société Anonyme. Acc. No. 1941.742.

Oil on burlap; 889 x 1161 mm. (35 x 45 11/16 in.).

Inscriptions: Signed at bottom right: JACQUES VILLON.

Provenance: Collection of the Société Anonyme, New York (bought from the artist in Paris in 1920).

Preparatory studies: Four preparatory drawings, three dated 1912, are reproduced in: D. Vallier, *Jacques Villon, oeuvres de 1897 à 1956* (Paris, 1957), pp. 44-45.

Exhibitions: Worcester, Mass., Worcester Art Museum, *Exhibition of Paintings by Members of the Société Anonyme*, 1921, no. 50; Springfield, Mass., The George Walter Vincent Smith Art Gallery, *Some New Forms of Beauty, 1909-1936, A Selection of the Collection of the Société Anonyme*, 1939, no. 67 [illustrated]; New Haven, Y.U.A.G., *Exhibition Inaugurating the Collection of the Société Anonyme*, 1942, no. 67; New Haven, Y.U.A.G., *Duchamp, Duchamp-Villon, Villon*, 1945, no. 1; Travelling Exhibition, 1945-46, *Duchamp, Duchamp-Villon, Villon*; Chicago, The Arts Club, *Villon*, 1952-53, no. 2; Minneapolis, Minn., The Walker Art Center, *The Classic Tradition in Contemporary Art*, 1953, no. 141; New York, Grace Borgenicht Gallery, *J. Villon*, 1955, no. 4; New York, Guggenheim Museum, *Duchamp, Duchamp-Villon, Villon*, 1957 (also shown in Houston, Texas, Museum of Fine Arts).

Bibliography: K. S. Dreier, *Western Art and the New Era* (New York, 1923), p. 83, fig. 37; G. H. Hamilton, "The Exhibition of the Collection of the Société Anonyme-Museum of Modern Art: 1920," *Bulletin*, Y.U.A.G., *10* (December, 1941); G. H. Hamilton, "Duchamp, Duchamp-Villon, Villon," *Bulletin*, Y.U.A.G., *13* (March, 1945), pp. 1-7, no. 1 [illustrated]; K. S. Dreier, J. J. Sweeney, and Naum Gabo, *Three Lectures on Modern Art.* (New York, 1949), p. 55 [illustrated]; K. S. Dreier and M. Duchamp, *Collection of the Société Anonyme: Museum of Modern Art 1920* (New Haven, 1950), p. 139.

Villon painted *La Table servie* about the same time he did his first important cubist canvas *Les soldats en marche* (1913), when he was closely associated with the other artists of the *Section d'Or*. Four drawings,[1] three of which are dated 1912, and a painting in the Steegmuller Collection[2] demonstrate step by step the analytical development of the composition: the first sketch simply records the subject; the next is a detailed study emphasizing light and shade; the third drawing outlines the big planes; the fourth shows the geometrical transformation through superimposed planes. This last drawing, even more advanced than the Steegmuller picture, might be considered the last preparatory study for the Yale version. A drypoint, dated 1913 and exhibited at the *Salon d'Automne* that year, certainly represents the ultimate stage in this series, and was probably made after *La Table servie*.[3] The place into which the Yale painting falls in this sequence suggests the date 1912-13.

1. D. Vallier, *Jacques Villon, oeuvres de 1897 à 1956* (Paris, 1957), pp. 44-45.
2. Ibid., p. 43 [illustrated].
3. For the drypoint, cf. J. Auberty and C. Perussaux, *Jacques Villon, catalogue de son oeuvre gravé* (Paris, 1950), no. 196.

IN MEMORIAM, 1919 (PLATE 32).

Collection of the Société Anonyme. Acc. No. 1941.741.

Oil on burlap; 1299 x 819 mm. (51⅛ x 32¼ in.).

Inscriptions: Signed at bottom left: JACQUES VILLON.

Provenance: Collection of the Société Anonyme, New York (bought from the artist in Paris in 1920).

Exhibitions: Worcester, Mass., Worcester Art Museum, *Exhibition of Paintings by Members of the Société Anonyme*, 1921, no. 51; New York, The Rand School of Social Science, *58th Exhibition of the Société Anonyme*, 1930, no. 13; Springfield, Mass., The George Walter Vincent Smith Art Gallery, *Some New Forms of Beauty, 1909-1936, A Selection of the Collection of the Société Anonyme*, 1939, no. 68

[illustrated]; New Haven, Y.U.A.G., *Exhibition Inaugurating the Collection of the Société Anonyme*, 1942, no. 36; New Haven, Y.U.A.G., *Duchamp, Duchamp-Villon, Villon*, 1945, no. 2; Travelling Exhibition, 1945-46, *Duchamp, Duchamp-Villon, Villon*; Boston, Institute of Contemporary Art, *Villon, Feininger*, 1949, no. 6 [illustrated]; Chicago, The Arts Club, *Jacques Villon*, 1952-53, no. 1; Berkeley, Cal., University of California, Department of Art, *Art from Ingres to Pollock*, 1960, p. 56 [illustrated opposite p. 44].

Bibliography: K. S. Dreier, *Western Art and the New Era* (New York, 1923), p. 83, fig. 38; G. H. Hamilton, "The Exhibition of the Collection of the Société Anonyme-Museum of Modern Art: 1920," *Bulletin*, Y.U.A.G., *10* (December, 1941); G. H. Hamilton, "Duchamp, Duchamp-Villon, Villon," *Bulletin*, Y.U.A.G., *13* (March, 1945), pp. 1-7, no. 2 [illustrated]; K. S. Dreier and M. Duchamp, *Collection of the Société Anonyme: Museum of Modern Art 1920* (New Haven, 1950), pp. 138-39 [illustrated].

Villon himself described the style of *In Memoriam*: "Towards the end of the war I treated the objects by breaking them up into planes. I proceeded by disposing the object in superimposed layers, a procedure which allowed me to give more expression to the volume. As every coat of color is shaded in tone, the result was a new object which found its source of light in itself."[1]

1. D. Vallier, *Jacques Villon, oeuvres de 1897 à 1956* (Paris, 1957), p. 66.

COLOR PERSPECTIVE, 1922 (PLATE 31).

Collection of the Société Anonyme. Acc. No. 1941.744.

Oil on canvas; 921 x 729 mm. (36¼ x 28 1/16 in.).

Inscriptions: Signed at bottom right: J. V; signed and dated on the reverse: *Jacques Villon 22*.

Provenance: Collection of the Société Anonyme, New York (bought from the artist in Paris in 1922).

Exhibitions: New Haven, Y.U.A.G., *Exhibition Inaugurating the Collection of the Société Anonyme*, 1942; New Haven, Y.U.A.G., *Duchamp, Duchamp-Villon, Villon*, 1945, no. 3; Travelling Exhibition, 1945-46, *Duchamp, Duchamp-Villon, Villon*; Chicago, The Arts Club, *Jacques Villon*, 1952-53, no. 4.

Bibliography: G. H. Hamilton, "The Exhibition of the Collection of the Société Anonyme-Museum of Modern Art: 1920," *Bulletin*, Y.U.A.G., *10* (December, 1941); G. H. Hamilton, "Duchamp, Duchamp-Villon, Villon," *Bulletin*, Y.U.A.G., *13* (March, 1945), pp. 1-7, no. 3; K. S. Dreier and M. Duchamp, *Collection of the Société Anonyme: Museum of Modern Art 1920* (New Haven, 1950), p. 139.

COLOR PERSPECTIVE, 1922 (PLATE 31).

Collection of the Société Anonyme. Acc. No. 1941.745.

Oil on canvas; 603 x 921 mm. (23¾ x 36¼ in.).

Inscriptions: Signed at bottom left: J. V; signed and dated on the reverse: *Jacques Villon 22*.

Provenance: Collection of the Société Anonyme, New York (bought from the artist in Paris in 1922).

Exhibitions: New Haven, Y.U.A.G., *Exhibition Inaugurating the Collection of the Société Anonyme*, 1942; New Haven, Y.U.A.G., *Duchamp, Duchamp-Villon, Villon*, 1945, no. 4; Travelling Exhibition, 1945-46, *Duchamp, Duchamp-Villon, Villon*; New York, Museum of Modern Art, *Paintings from New York Private Collections*, 1946, no. 325; Chicago, The Arts Club, *Jacques Villon*, 1952-53, no. 4.

Bibliography: G. H. Hamilton, "The Exhibition of the Collection of the Société Anonyme-Museum of Modern Art: 1920," *Bulletin*, Y.U.A.G., *10* (December, 1941); G. H. Hamilton, "Duchamp, Duchamp-Villon, Villon," *Bulletin*, Y.U.A.G., *13* (March, 1945), pp. 1-7, no. 4 [illustrated]; K. S. Dreier and M. Duchamp, *Collection of the Société Anonyme: Museum of Modern Art 1920* (New Haven, 1950), p. 139.

Both of the Yale paintings entitled *Color Perspective* represent Villon's most abstract style of angular superimposed planes of bright contrasting colors, organized parallel to the picture surface. This nonobjective style – proceeding from the principles of synthetic cubism – marks only a very short period in Villon's work during the early twenties.

LE JOCKEY, 1924 (PLATE 33).

Collection of the Société Anonyme. Acc. No. 1941.746.

Oil on canvas; 646 x 1276 mm. (25 7/16 x 50¼ in.).

Inscriptions: Signed and dated at bottom right: JACQUES VILLON *24*.

Provenance: Collection of the Société Anonyme, New York (bought from the artist in Paris in 1924).

Preparatory studies: There are eight preparatory drawings for *Le Jockey* in the Y.U.A.G., 1941.748-1941.755. In the exhibition catalogue *Jacques Villon, Master of Graphic Art* (Boston, Museum of Fine Arts, 1964), p. 22 and nos. 165-67, three more studies are published.

Exhibitions: New York, Brooklyn Museum, *An International Exhibition of Modern Art Assembled by the Société Anonyme*, 1926, no. 57; New York, Anderson Galleries, *International Exhibition of Modern Art Assembled by the Société Anonyme*, 1927, no. 32; New York, The Rand School of Social Science, *58th Exhibition of the Société Anonyme*, 1930, no. 14; New Haven, Y.U.A.G., *Exhibition Inaugurating the Collection of the Société Anonyme*, 1942, no. 13; New Haven, Y.U.A.G., *Duchamp, Duchamp-Villon, Villon*, 1945, no. 5; Travelling Exhibition, 1945-46, *Duchamp, Duchamp-Villon, Villon*; Providence, R. I., Rhode Island School of Design, Museum of Art, *Isms in Art Since 1800*, 1949; Boston, Institute of Contemporary Art, *Villon, Feininger*, 1949, no. 9; Chicago, The Arts Club, *Jacques Villon*, 1952-53, no. 6; New York, Grace Borgenicht Gallery, *Villon*, 1955, no. 8.

Bibliography: G. H. Hamilton, "The Exhibition of the Collection of the Société Anonyme-Museum of Modern Art: 1920," *Bulletin*, Y.U.A.G., *10* (December, 1941); G. H. Hamilton, "Duchamp, Duchamp-Villon, Villon," *Bulletin*, Y.U.A.G., *13* (March, 1945), pp. 1-7, no. 5 [illustrated]; G. H. Hamilton, "The Dialectic of Later Cubism: Villon's Jockey," *Magazine of Art*, *41* (1948), pp. 268 ff. [illustrated]; K. S. Dreier and M. Duchamp, *Collection of the Société Anonyme: Museum of Modern Art 1920* (New Haven, 1950), pp. 139-40; R. Rosenblum, *Cubism and 20th Century Art* (New York, 1960), p. 105 [illustrated].

With *The Jockey* Villon returns to a figurative subject transforming it step by step to a composition of superimposed planes, as shown by the series of numbered preparatory drawings. The object, first studied carefully in detail, goes through various analytical reductions toward the final pictorial composition, a process very similar to that of the genesis of *La Table servie*.

SEATED GIRL, 1936 (PLATE 32).

Collection of the Société Anonyme. Acc. No. 1941.743.

Oil on canvas; 810 x 599 mm. (37⅞ x 23 9/16 in.).

Inscriptions: Signed and dated at bottom right: JACQUES VILLON *36*.

Provenance: Collection of the Société Anonyme, New York (bought from the artist in Paris in 1937).

Exhibitions: Springfield, Mass., The George Walter Vincent Smith Art Gallery, *Some New Forms of Beauty, 1909-1936, A Selection of the Collection of the Société Anonyme*, 1939, no. 69; New Haven, Y.U.A.G., *Exhibition Inaugurating the Collection of the Société Anonyme*, 1942, no. 63; New Haven, Y.U.A.G., *Duchamp, Duchamp-Villon, Villon*, 1945, no. 14; Travelling Exhibition, 1945-46, *Duchamp, Duchamp-Villon, Villon*; Chicago, The Arts Club, *Jacques Villon*, 1952-53, no. 3.

Bibliography: G. H. Hamilton, "The Exhibition of the Collection of the Société Anonyme-Museum of Modern Art: 1920," *Bulletin*, Y.U.A.G., *10* (December, 1941); G. H. Hamilton, "Duchamp, Duchamp-Villon, Villon," *Bulletin*, Y.U.A.G., *13* (March, 1945), pp. 1-7, no. 14; K. S. Dreier and M. Duchamp, *Collection of the Société Anonyme: Museum of Modern Art 1920* (New Haven, 1950), p. 140.

Edouard Vuillard
Cuiseaux (Saône-et-Loire) 1868 –
La Baule (Loire-Inférieure) 1940

LA CUISINE, C. 1891-92 (PLATE 22).
(The Kitchen)

The Philip L. Goodwin Collection, B.A. 1907. Acc. No. 1958.21.

Oil on heavy cardboard; 173 x 338 mm. (6¾ x 13 5/16 in.).

Inscriptions: Signed at bottom right: *E. Vuillard;* annotated

on reverse with pencil, probably not in the artist's hand: *Vuillard Mai 11 91.* Unfinished oil sketch on reverse; interior with still life (flower vase).

Provenance: Sam Salz, Paris (bought from the artist in 1938-39); Alfred Daber, Paris; Philip L. Goodwin, New York.

Exhibitions: Probably Paris, Musée des Arts Décoratifs, *Vuillard,* 1938, no. 25; Paris, Galerie Alfred Daber, *Bonnard-Vuillard,* 1941; Paris, Galerie Alfred Daber, *Petit Salon de la nature morte,* 1942; Bern, Kunsthalle, *E. Vuillard, A. Muellegg,* 1946, no. 34 [as *La Cuisinière*]; New Haven, Y.U.A.G., *Pictures Collected by Yale Alumni,* 1956, no. 126 [illustrated].

Bibliography: "The Art Acquired by Yalemen," *Life* (May 28, 1956), p. 71 [illustrated]; "Recent Gifts and Purchases," *Bulletin,* Y.U.A.G., *24-25* (April, 1959), p. 30 [illustrated].

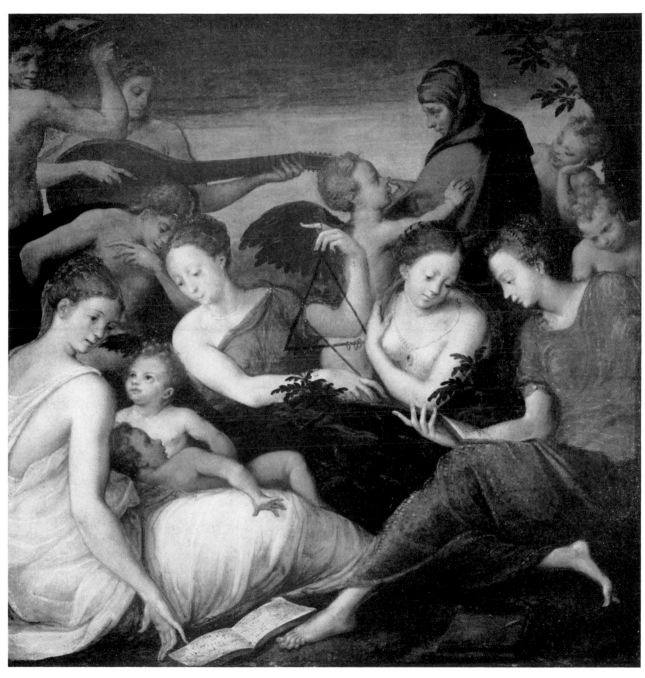

Plate 1
School of Fontainebleau, *Le Concert,* after 1556 (p. 9)

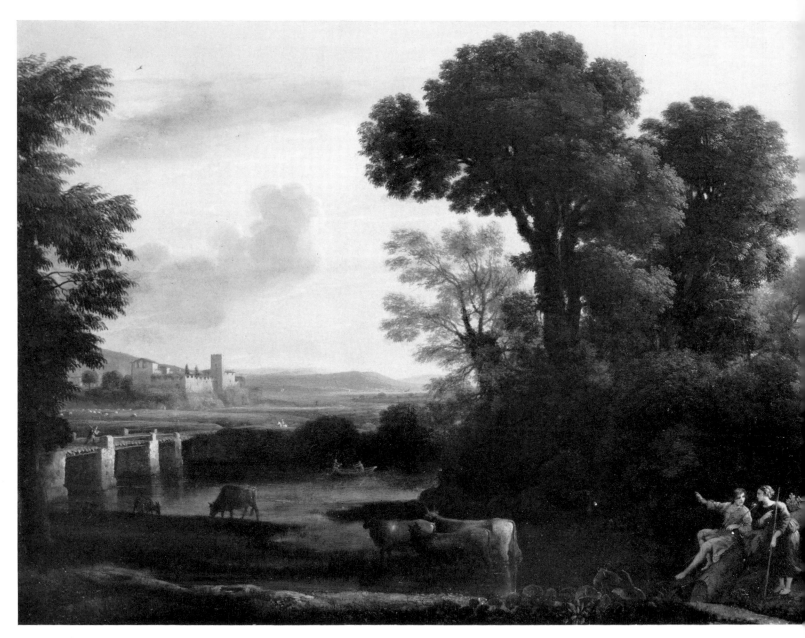

Plate 2
Claude, *Pastoral Landscape*, 1648 (p. 10)

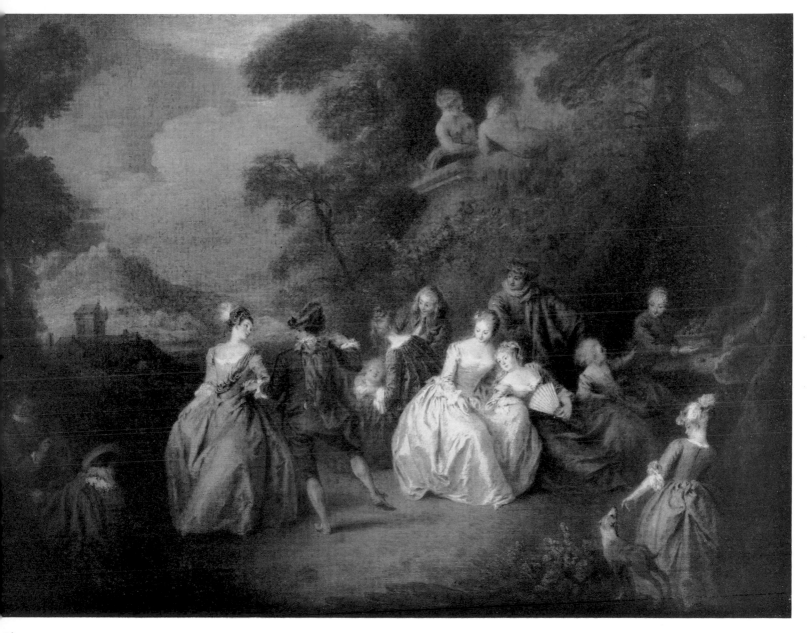

Plate 3
Pater, *Scène Galante dans un Parc*, c. 1725-35 (p. 19)

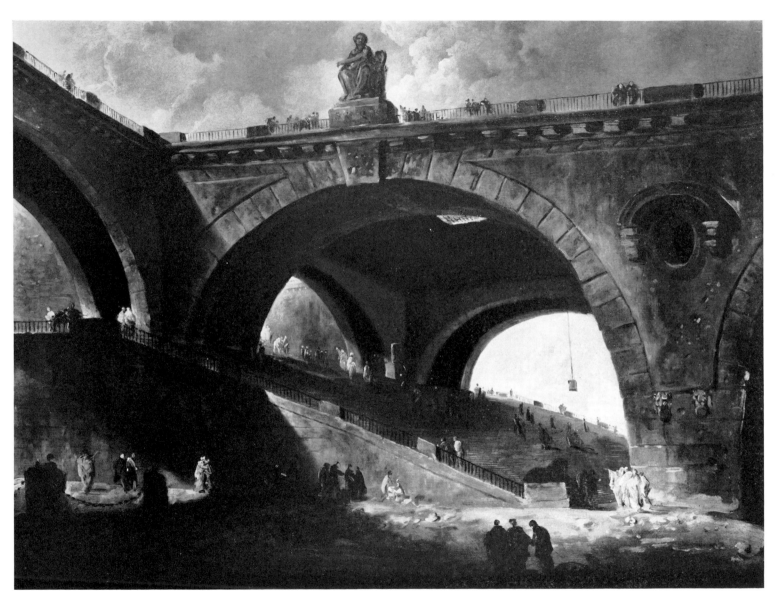

Plate 4
Robert, *Le Pont Ancien*, c. 1760–65 (p. 25)

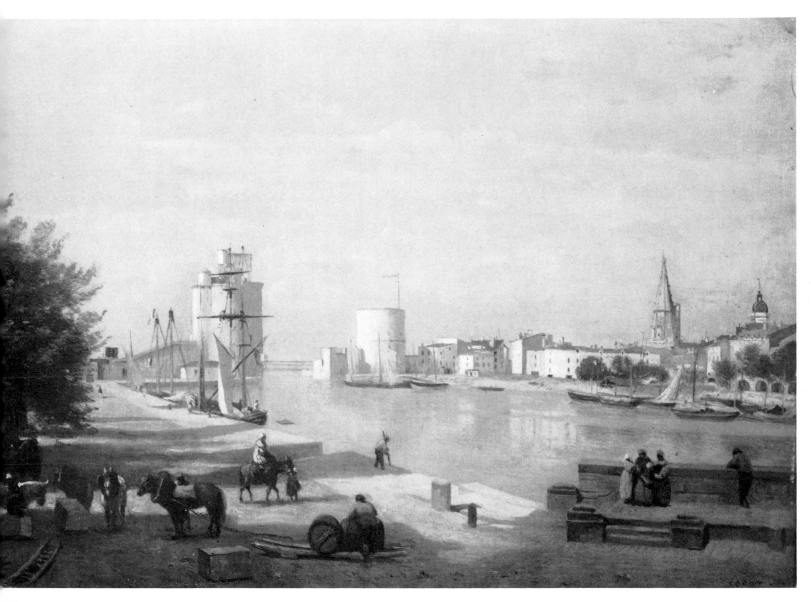

Plate 5
Corot, *Le Port de La Rochelle*, 1851 (p. 4)

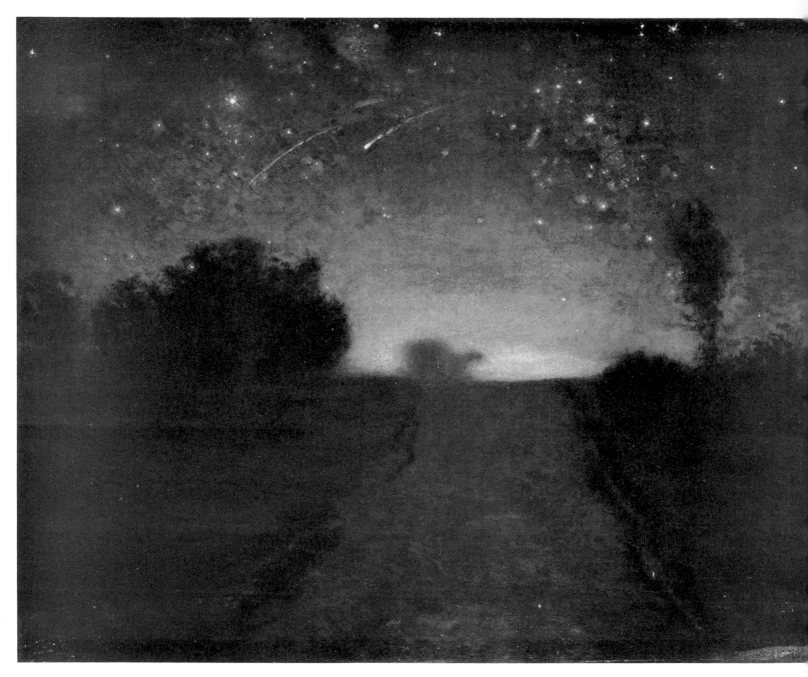

Plate 6
Millet, *Nuit Etoilée*, c. 1850–51 (p. 18)

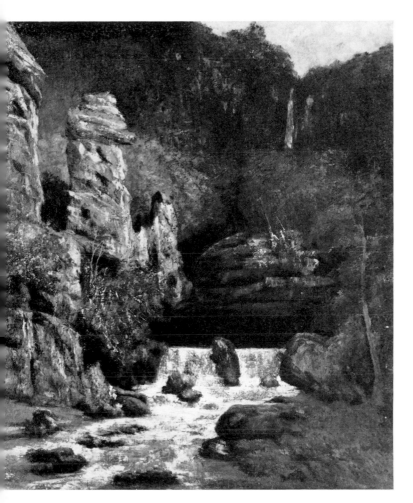

Plate 7
Courbet, *La Source du Loue*, c. 1864 (p. 5)
Courbet, *Bords du Doubs; Effet d'Automne*, 1866 (p. 5)

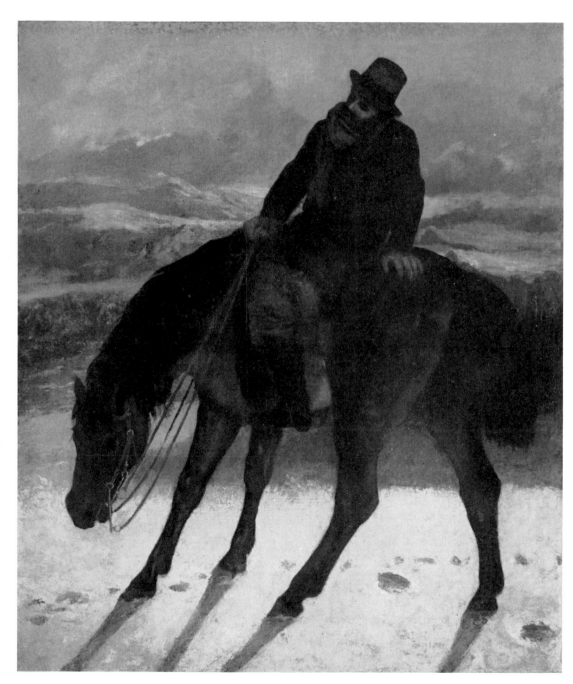

Plate 8
Courbet, *Chasseur à Cheval*, 1867 (p. 5)

Plate 9
Monticelli, *The Barnyard*, c. 1865 (p. 19)
Monticelli, *Garden Scene*, c. 1875-78 (p. 19)

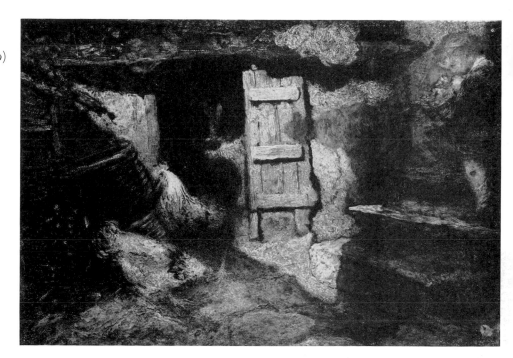

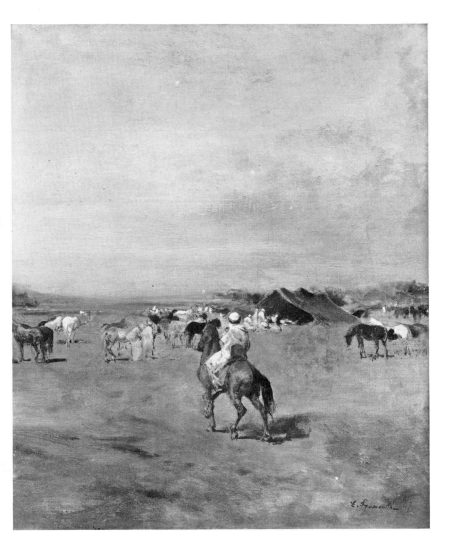

Plate 10
Fromentin, *Arabian Encampment,* 1847 (p. 10)
Boudin, *Trouville,* c. 1865-70 (p. 1)

Plate 11
Boudin, *Beach Scene*, c. 1874–75 (p. 1)
Boudin, *Harbour Scene with Ships*, c. 1875 (p. 1)

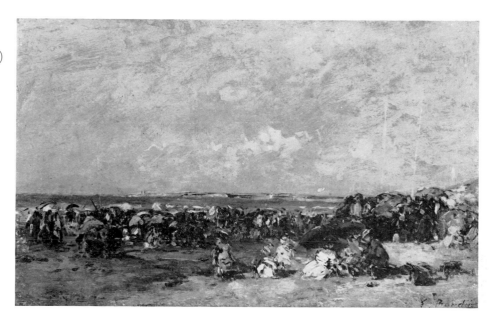

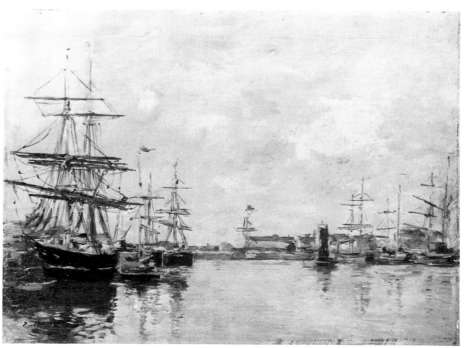

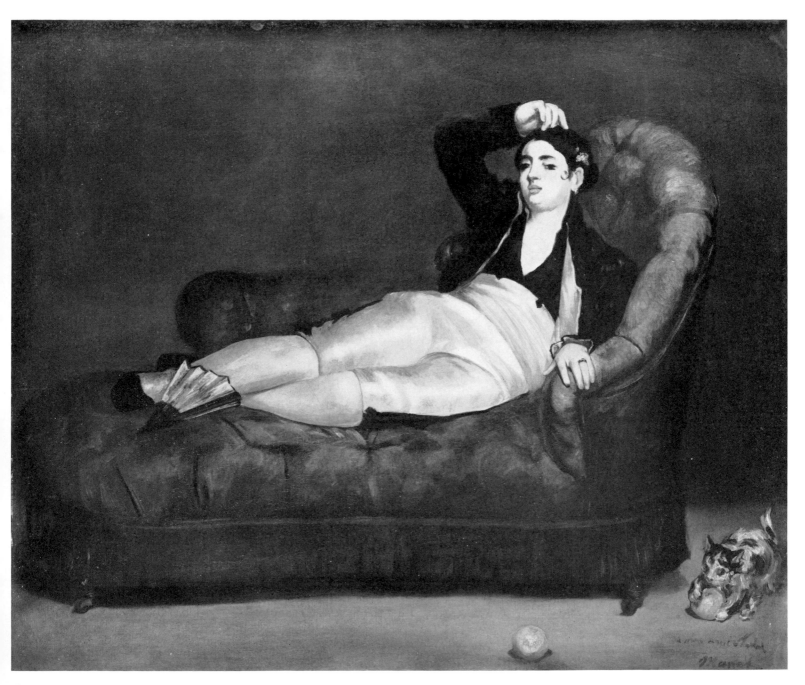

Plate 12
Manet, *Jeune Femme Couchée en Costume Espagnol*, 1862–63 (p. 15)

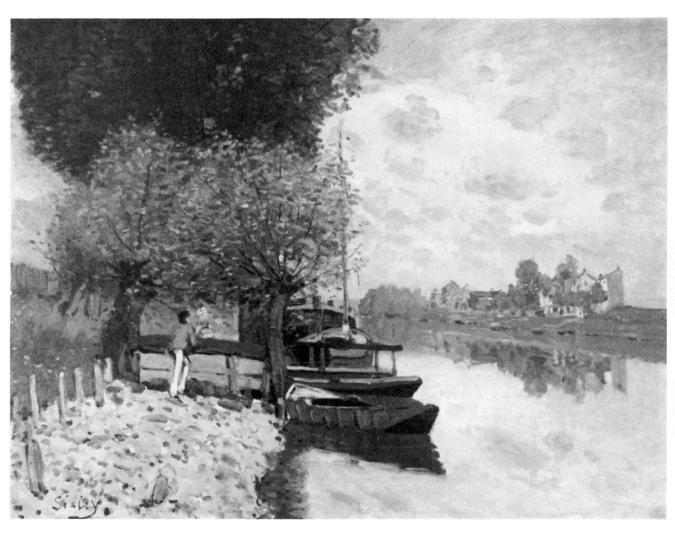

Plate 13
Sisley, *La Seine à Bougival*, 1872 (p. 26)

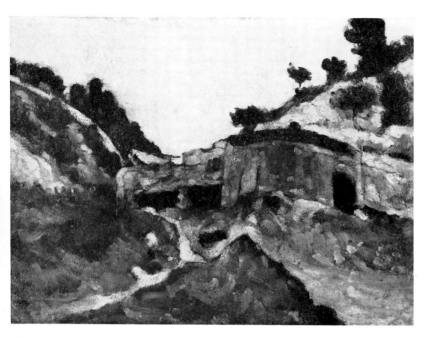

Plate 14
Cézanne, *Paysage avec Moulin à Eau*, c. 1870-71 (p. 3)
Cézanne, *Le Chemin du Village*, c. 1872-74 (p. 3)

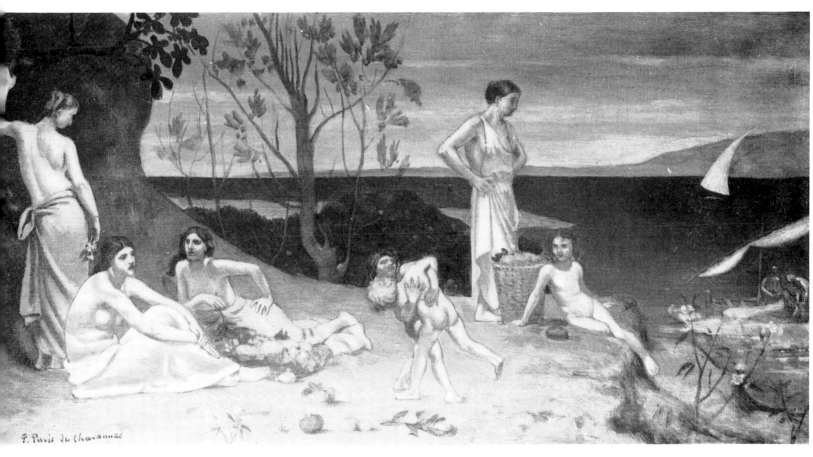

Plate 15
Puvis de Chavannes, *Doux Pays*, 1882 (p. 22)

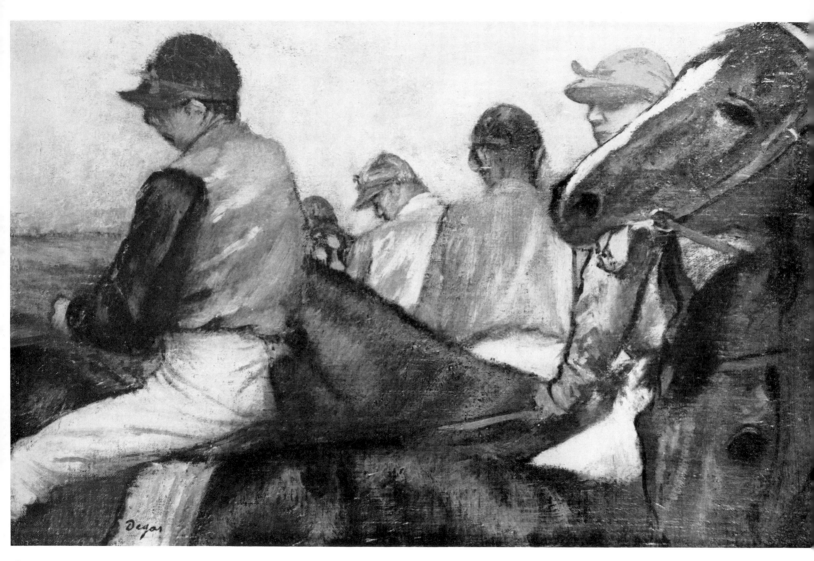

Plate 16
Degas, *Jockeys*, c. 1881–85 (p. 6)

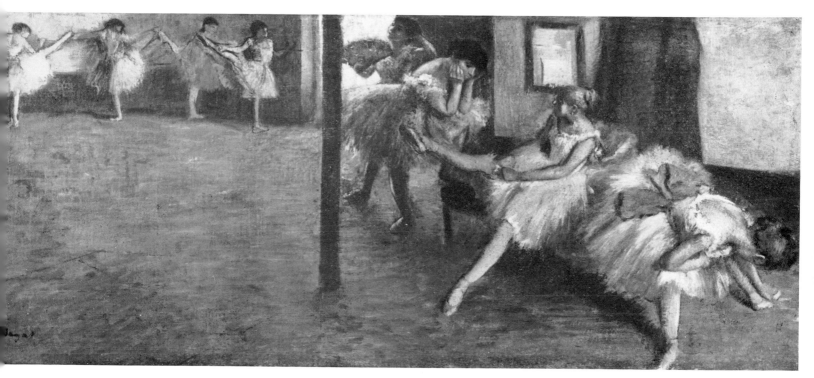

Plate 17
Degas, *La Salle de Danse*, c. 1891 (p. 7)

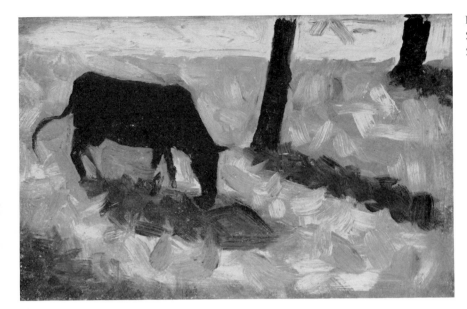

Plate 18
Seurat, *Black Cow in a Meadow*, c. 1881 (p. 25)
Seurat, *Two Stonebreakers*, c. 1881 (p. 26)

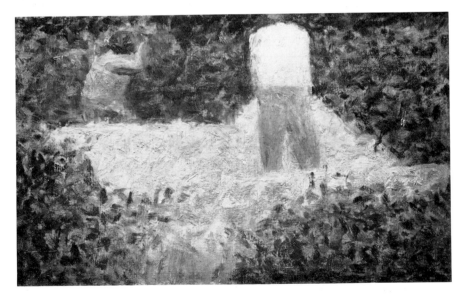

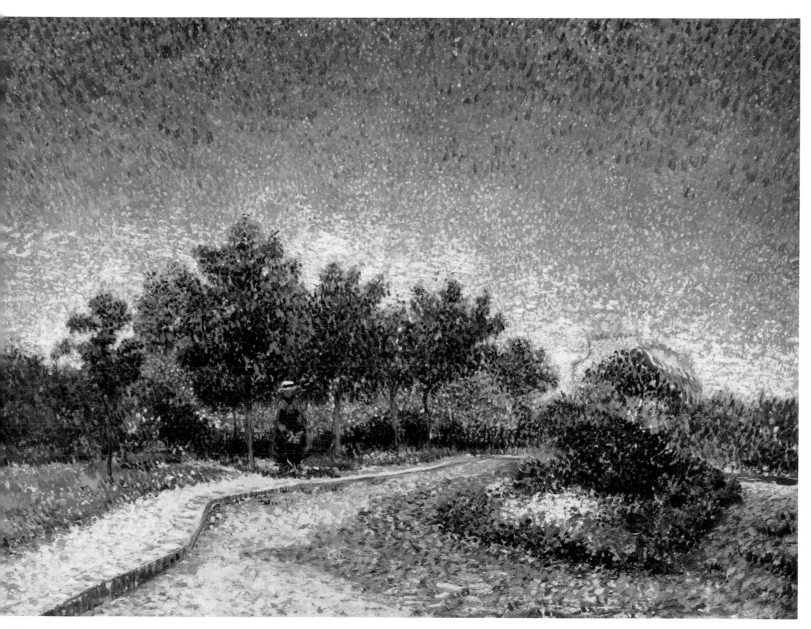

Plate 19
Van Gogh, *Coin de Parc*, c. 1886–87 (p. 11)

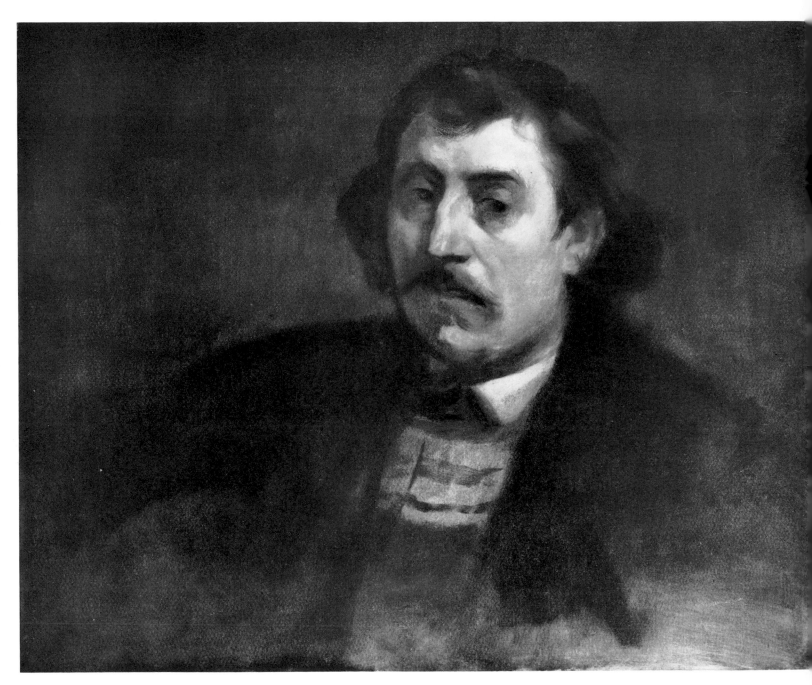

Plate 20
Carrière, *Portrait of Paul Gauguin*, 1891 (p. 2)

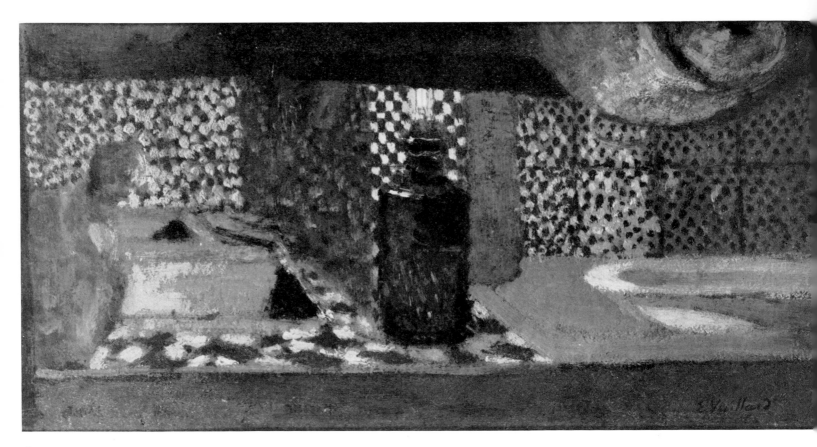

Plate 22
Vuillard, *La Cuisine*, c. 1891-92 (p. 29)

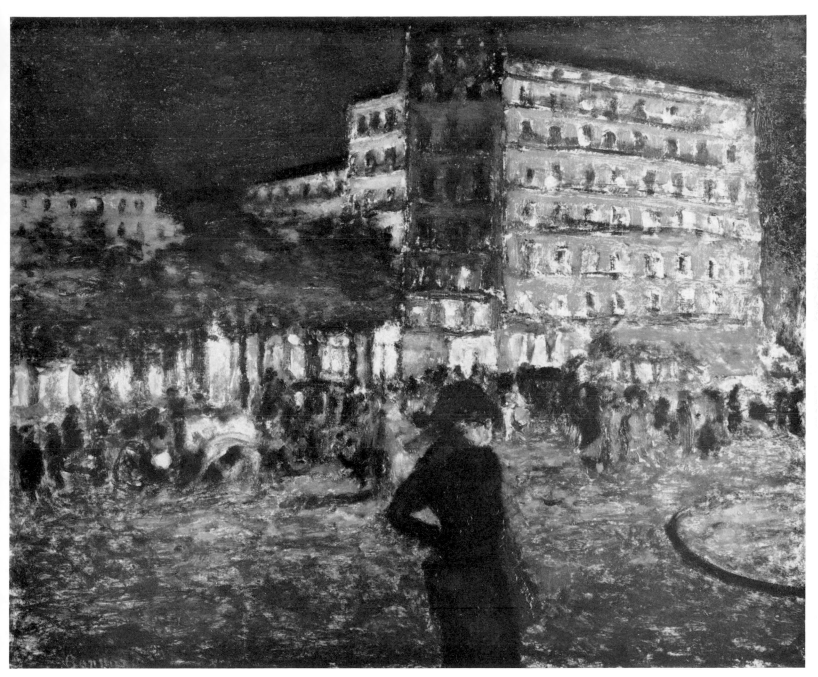

Plate 23
Bonnard, *Place Pigalle, La Nuit*, c. 1905–08 (p. 1)

Plate 24
Redon, *Apollo*, c. 1905–10 (p. 23)

Plate 25
Matisse, *Nature Morte:*
A la Statuette, 1906 (p. 17)

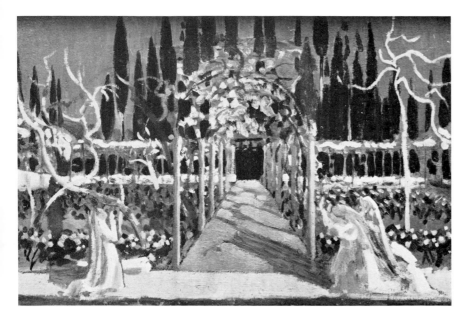

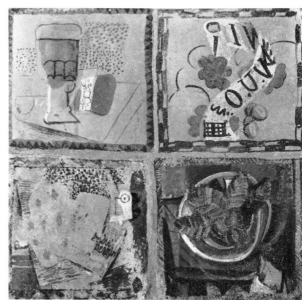

Plate 26
Denis, *Annonciation Marie*, 1907 (p. 8)
Utrillo, *Rue de Village*, c. 1910 (p. 26)
Derain and Picasso, *Four Tiles with Still Lifes*, c. 1914 (p. 8)

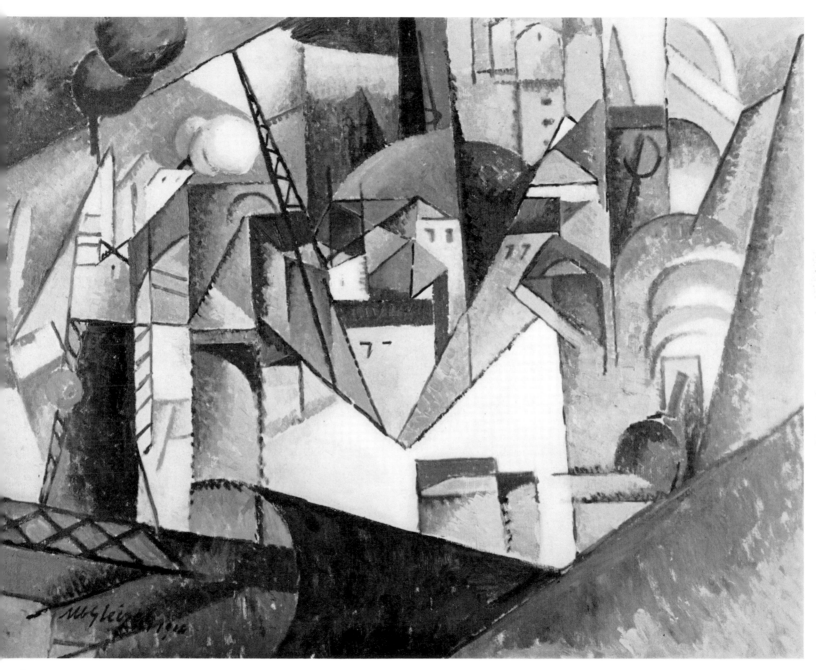

Plate 27
Gleizes, *Paysage*, 1914 (p. 10)

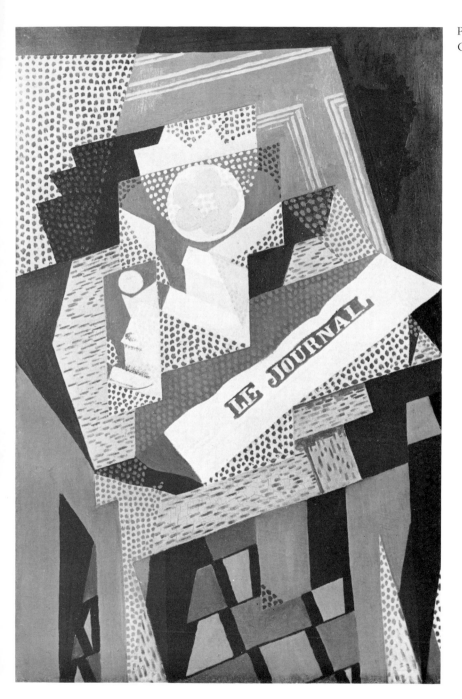

Plate 28
Gris, *Abstraction No. 2: Le Journal*, 1916 (p. 13)

Plate 29
Gris, *Still Life*, 1916 (p. 14)

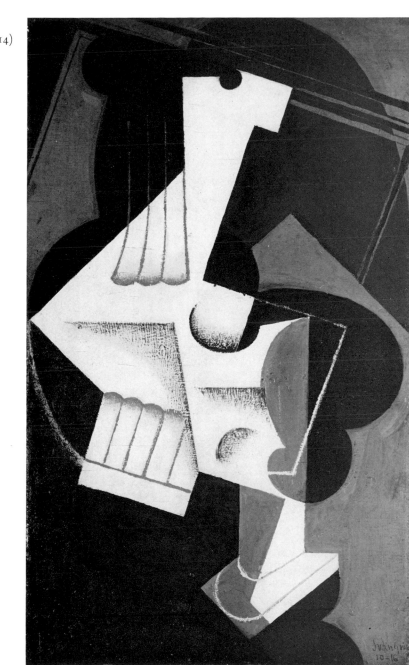

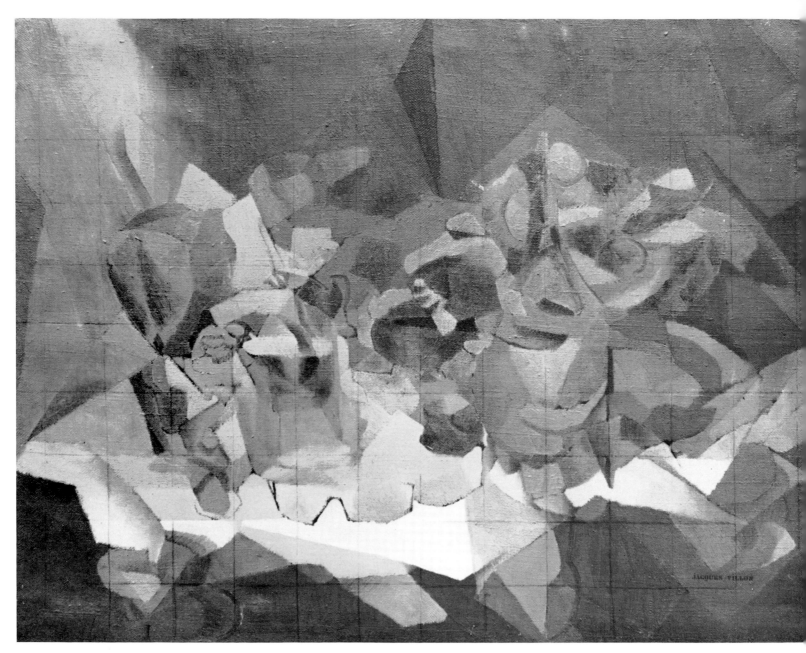

Plate 30
Villon, *La Table Servie*, 1912-13 (p. 27)

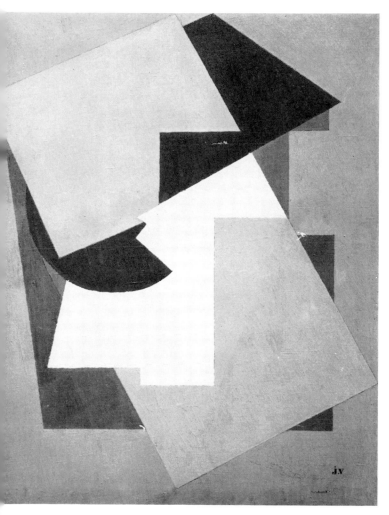

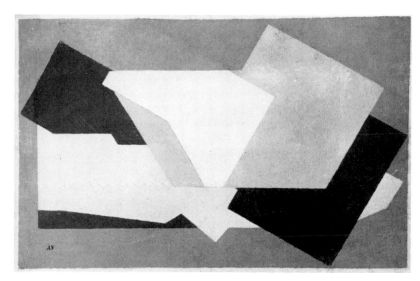

Plate 31
Villon, *Color Perspective*, 1922 (p. 28)
Villon, *Color Perspective*, 1922 (p. 28)

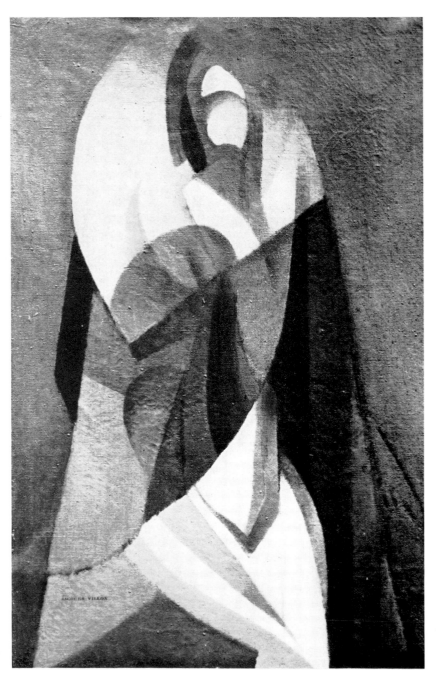

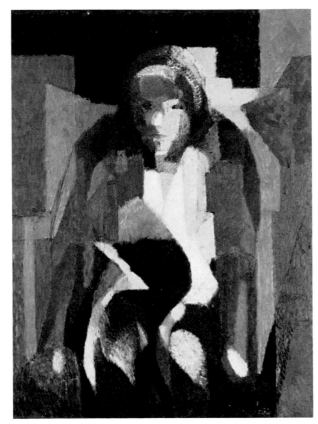

Plate 32
Villon, *In Memoriam*, 1919 (p. 27)
Villon, *Seated Girl*, 1936 (p. 29)

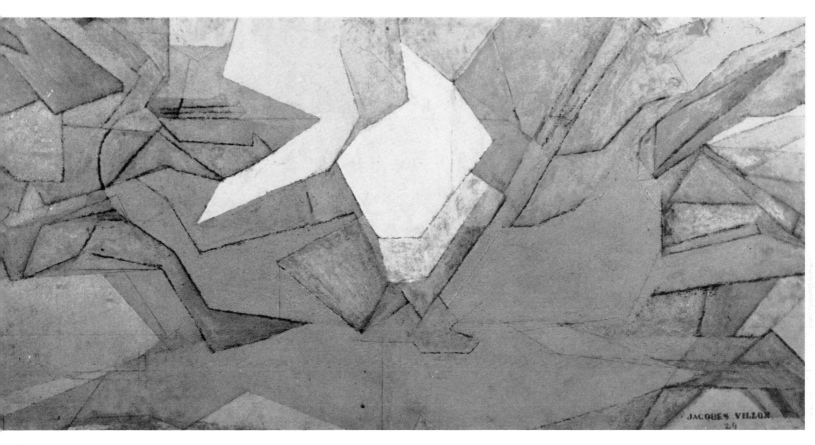

Plate 33
Villon, *Le Jockey*, 1924 (p. 28)

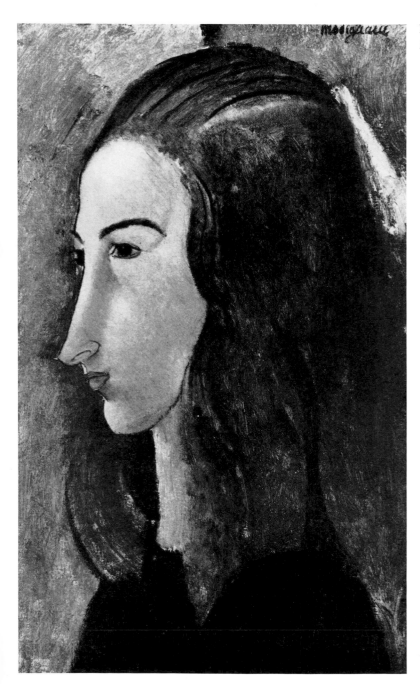

Plate 34
Modigliani, *Portrait of a Young Woman*, c. 1918 (p. 18)

Plate 35
Ribemont-Dessaignes, *Jeune Femme*, c. 1918 (p. 24)

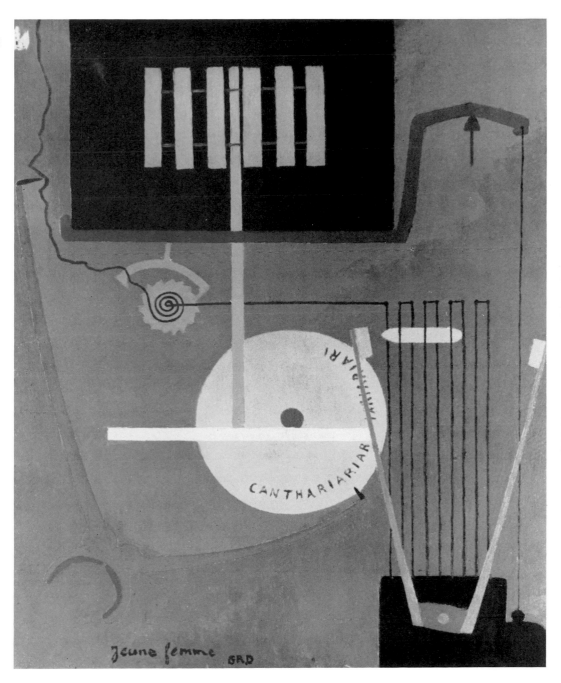

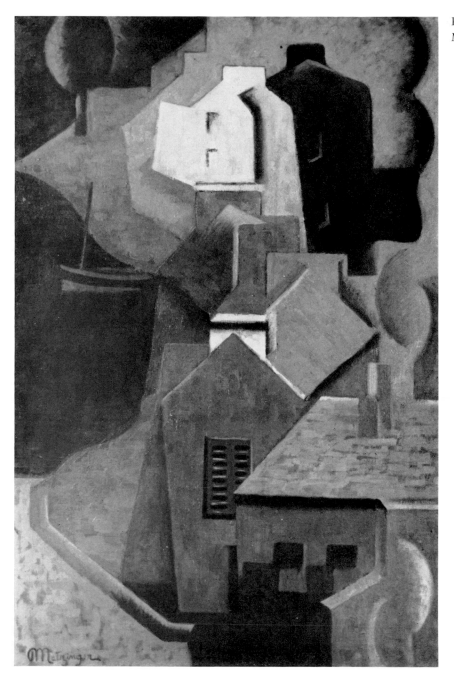

Plate 36
Metzinger, *Le Port,* 1920 (p. 17)

Plate 37
Picabia, *Midi*, c. 1920–29 (p. 20)
Derain, *Route du Midi*, c. 1920–25 (p. 8)

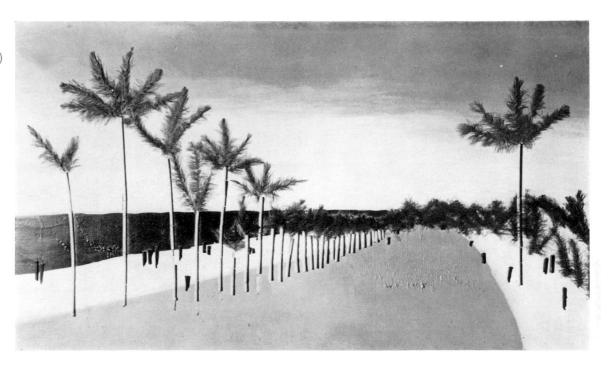

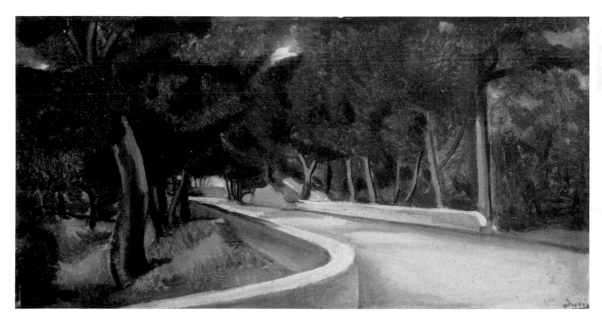

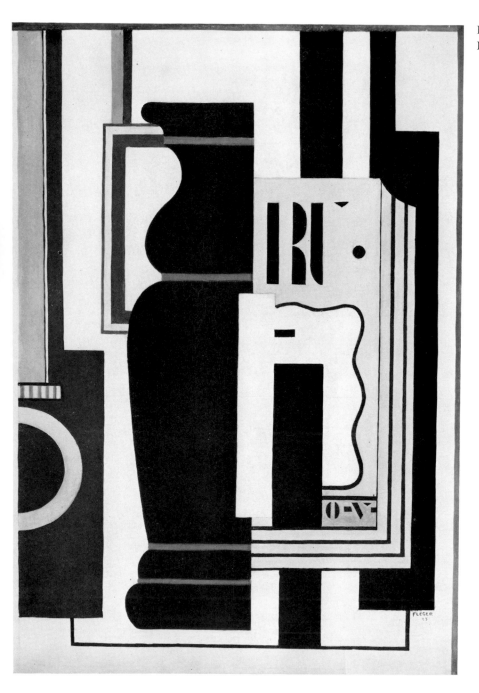

Plate 38
Léger, *Composition No. 7*, 1925 (p. 14)

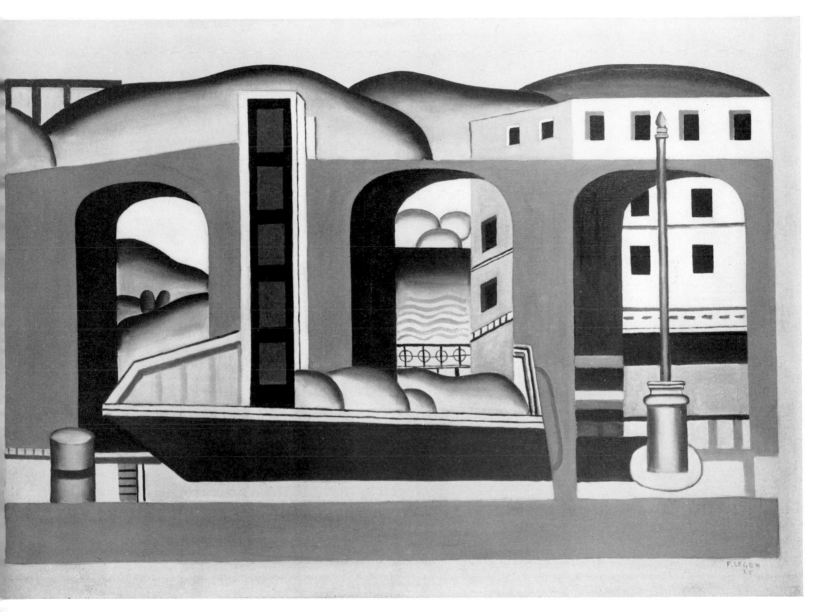

Plate 39
Léger, *Le Viaduc*, 1925 (p. 15)

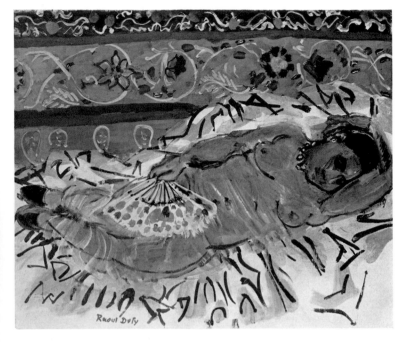

Plate 40
Dufy, *Le Modèle Hindou*, c. 1929 (p. 8)
Picasso, *Corbeille de Fleurs et Pichet*, 1937 (p. 21)

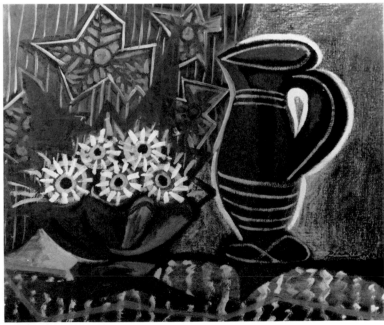

Plate 41
Picasso, *Chien et Coq*, 1921 (p. 20)

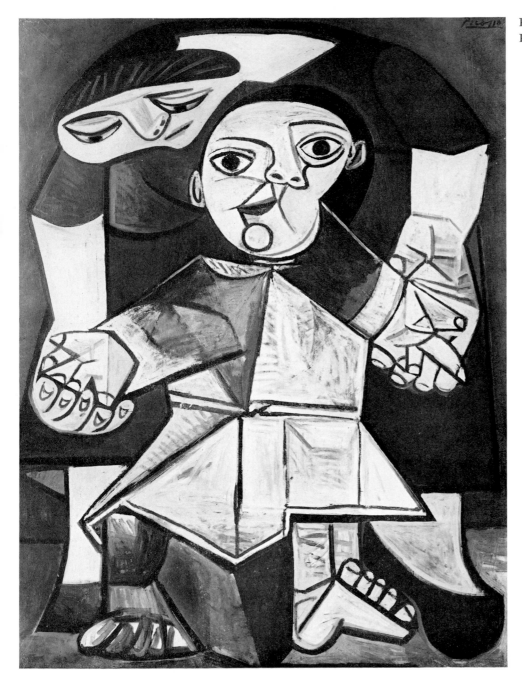

Plate 42
Picasso, *Les Premiers Pas*, 1943 (p. 21)

Plate 43
Braque, *Le Poële*, 1942–43 (p. 1)